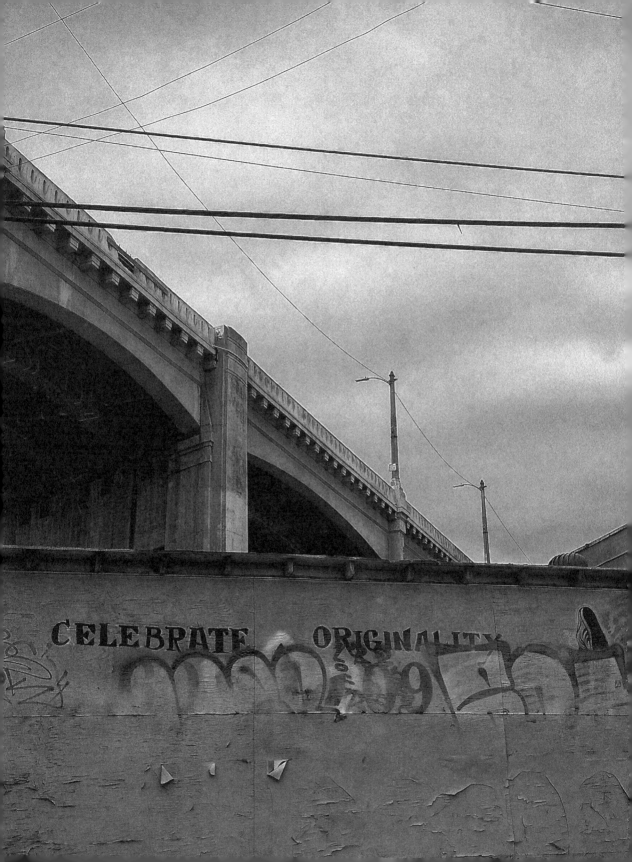

After / Image

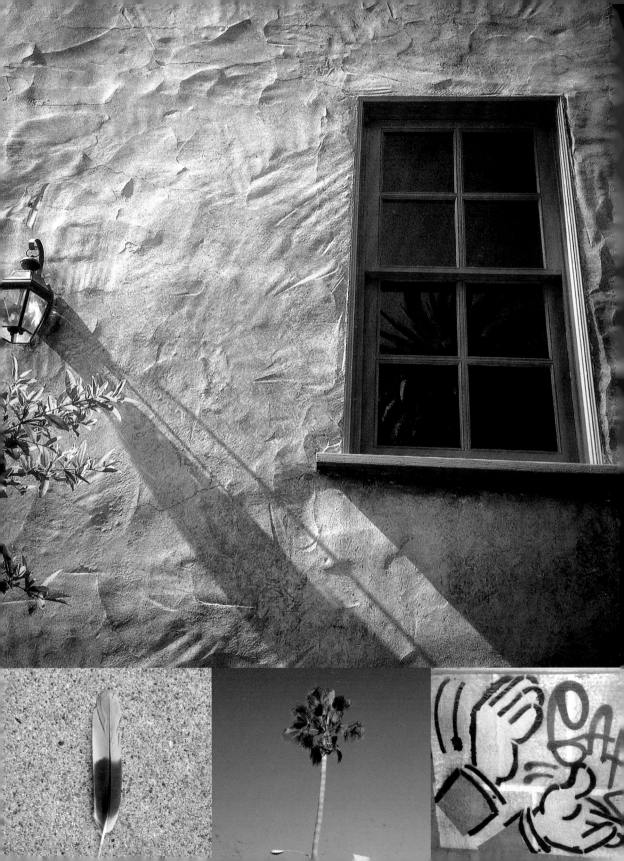

After / Image

Los Angeles Outside the Frame

Lynell George

ACP
ANGEL CITY PRESS

Contents

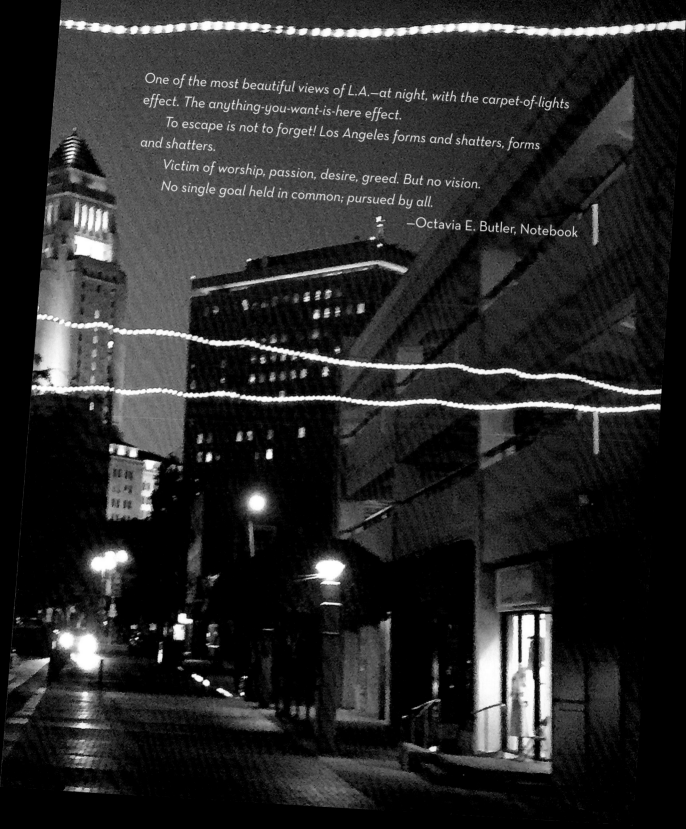

One of the most beautiful views of L.A.—at night, with the carpet-of-lights effect. The anything-you-want-is-here effect.

To escape is not to forget! Los Angeles forms and shatters, forms and shatters.

Victim of worship, passion, desire, greed. But no vision. No single goal held in common; pursued by all.

—Octavia E. Butler, Notebook

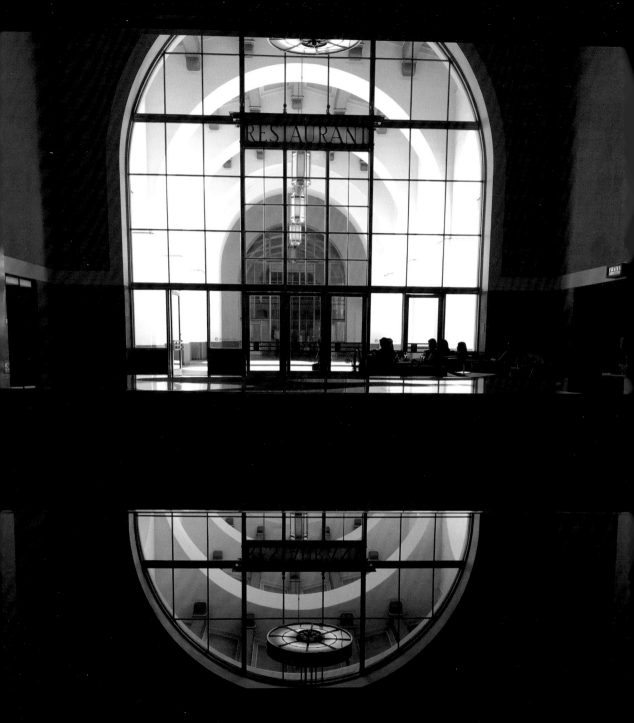

1 *City of the Future's Past: An Introduction*

SOMETIMES WHEN I TURN a corner here in Los Angeles, I'm haunted by a sensation.

It's pure feeling: that jittery excitement that accompanies waiting for someone—or something—dear to arrive. It's pressing closer, the suggestion of it, but still too far off to see a sure shape or contours.

And then.

Maybe you blink or are in some other way distracted, and somehow when you refocus, it's passed by. That moment is receding. Gone. Impossible to recover. That's often how I feel about Los Angeles. There was something complex and beautifully imperfect that we were building in a wild mix of languages, cultures, and experimentation. We would try to build bridges across difference and the distances of fear—or hate. So many of us brought rituals and language and expectations from elsewhere; and in this new proximity, something new grew out of the soil. For a while.

For some time, I truly thought the Los Angeles that was on the way would be the best of all of that—even with the chaos and rough edges and failures of imagination. What were we building with our bare hands,

broken-and-or-improvised languages, and bad backs?

What I'm left with now is an arrangement of streets that if I squint, look familiar, but they are cul-de-sacs of fading memory, a circle of "what ifs?" Too often, I hear stories about people being nudged to the edges or pushed out of their hard-won homes. And more frequently than I like to acknowledge, I hear someone grousing about the "unfriendly new people" or lamenting the tossed-out bits and pieces of a former life here, ghosts of rituals and memories that they step over as they go on with their day. Add to that list of laments: too many discussions about exit strategies—quality of life issues, traffic, violence, expense, intolerance, and impatience sharpened to abrasiveness. And it's then I must stop and ask—not them, but myself—not just when did I become the person marooned in punishing traffic at all hours, banging on the steering wheel, but when was the last time I wasn't?

As deeply as I love and have come to understand my native city—its size and shape and equivocal nature—recently, as I move through it, I have become more and more perplexed.

<p style="text-align:center">✴</p>

I seem to have "lost" Los Angeles. It's as if the city were a set of keys I've somehow misplaced. I keep frantically retracing my steps hoping to locate it—*something's lost and must be found.*

As a native Angeleno, I've grown accustomed to a shape-shifting landscape. I have spent most of my life here thinking about sense of place—traveling across wide stretches of it, burrowing deep into it, attempting to write the many cities Los Angeles has come to be onto the page. Much of my writing has been an attempt to pull Los Angeles into focus for those on the outside, yes, but often really for myself.

More quickly now, however, as the skies above me have become a busy latticework of construction cranes and towering skeletons of drywall and steel, I find myself knocked off balance by the dramatic, sometimes whole-

sale, upheavals. As, I pass through what should be familiar thoroughfares; I see both hints of the past and previews of the future. The present has always been difficult to hold on to. We live with memory of memories.

More than ever, I find myself stopping to consider what all that subtraction might ultimately amount to. When I say I am *from* Los Angeles, what precisely does that mean? When change and a recalibration of the present is a constant, a process, what does it mean when you live around—or at the fringes of—an image that is projected? What does it mean to understand yourself amid the clutter of outsiders' expectations of Los Angeles?

In the last few years, I have been making a ritual out of recording that vanishing sense of place—in essays and interviews and photographs. Something at the edges of my own consciousness told me I might need to. I started rising early Sundays, when the city was emptied out, or it was just blinking awake, so I could better see what was before me. Sitting in traffic on my way to work for two hours, each way, (only to do it again come morning) had blotted much of that out. What was the city on the ground? Close up. That day-to-day city? I wanted to get back to it. Reconnect maybe.

I wasn't interested in what is beamed out as the stock imagery of Los Angeles—either a montage of upscale delights or a blur of dysfunction—but the details, experiences, and people I've come to know and associate as "home."

I had come to a destination in my mind: I wanted to find and catalog what and who is still here. What is Los Angeles when you pull the image of the city away? What are you left with? What is the Los Angeles that lives inside of us? The one—the afterimage—that lingers in the mind's eye.

In that time, I have been looking squarely at what persists. These photos and notes and dovetailing conversations that comprise *After/Image* are evidence of life lived here as nowhere else. These vignettes express the way I've been experiencing the city of late, as I pass through places that possess something so unique, so idiosyncratic—a scent, a cast of light, a melody tumbling out a moving car window—and allow me, if only briefly, to float within an

old sense of familiarity.

I suppose, as writers often do, I am trying to write myself back home. Wandering the city, taking photographs, I realize has been a way to look for connections. But mostly, I realize, my quests have been attempts to find remnants of the place I grew up in, before it all slips away. Ghost signs. The last pieces of the familiar turns in the roads. Words into maps, maps into words. I walk to remember, to tell and honor those stories. So much change, I've come to realize, makes one question whether or not a place ever existed at all.

In the midst of all of this reconsideration, I'd been asked to sit on yet another panel about changing Los Angeles, and the earnest moderator asked each of us—two transplants, two natives—what Los Angeles we wanted to live in. I found myself pausing, trying to call up an answer that didn't feel glib, but one that felt revealing and from the heart. It took a long minute, but a vision came; that one I see both in my rearview and still floating—just ahead—in what seems, at times, an unreachable distance. It's a Los Angeles of frank co-existence, of pluralism that we have to make and make room for, instead of always reflexively comparing it to other places or twisting it into some new fantasy we will never achieve.

After all of the wandering and long conversations and writing, I can't quite say if this narrative—the photographs, the essays, the testimonials—is a love letter or a Dear John note. I feel a strong sense of ambivalence about Los Angeles that I've never felt before. I'm not alone. I hear it, among other longtime, deep-rooted Angelenos, this dissonant harmony—a lament—threading just beneath the sunny surface. And too, not just words, but actions: I've sat on the floor wrapping passed-down china in newsprint, helping friends carefully pack moving boxes. I listen to last-straw testimonials: Farewells from old colleagues or neighbors who have had it with *Well, does it really matter?* "It's time," as one friend offered, exasperatedly. "Now,

before all I'm doing is living in a memory."

 I understand.

 Finding balance here—a sense of belonging and a sense of place—I know is both a constant practice of reclamation and a ritual of remembering.

 So for now, here is my Los Angeles—my here-and-now Los Angeles.

<div align="right">—December 2017</div>

2 *Lost Angelena*

WE'VE ARRIVED AT the part of the evening that should be easy conversation—dinner cleared, twilight descending, the valleys of small talk safely crossed. Inevitably though, someone casts about for "there-to-here" stories: oral postcards from the West. The back-and-forth of this particular late-winter evening doesn't seem much different than so many others I've spent—at least not at first.

Another guest, not surprisingly, is also "from Los Angeles." Although, "Not originally," she's quick to clarify. "It wasn't my first choice," she continues, defensiveness edging her voice. Rather, it was a "decision of expedience." Good job. Possibility to grow. The set of her jaw telegraphed the truth: "It hasn't happened," she pauses. That magic "it" aloft.

"Los Angeles is just so ugly."

When you're a native Angeleno, on land away from home, you learn to know it's coming. That salvo. In that "ugly" I hear a universe—some dissonance between expectation and truth.

Usually, in moments like this, I'm the one to unscroll my script, say my lines. Not this time. Even in the darkness, I feel eyes sliding my way: *Say something. You usually do.*

I always come to Los Angeles's defense. I'm the one who rattles off the

oh-so-many ways Los Angeles is misunderstood—or misunderstands itself—in a tone usually reserved for a wayward-but-adored relation.

I sit in silence; a growing void surprises no one more than me.

For weeks, I pondered that pause: Why didn't I jump into the breach? Was there something lurking behind inaction? Had my gut made a decision that my head had yet to come to?

I am not a booster, nor am I the city's apologist. I see Los Angeles's flaws and rail against foolish decisions made on its behalf that alter its face, its soul. (Football stadium. Downtown. Really?) Seldom, I've come to note, does any other city inspire such bare-knuckled contempt?—particularly from those who choose to come here? But now I wonder about my own ambivalence that supper-table silence suggested.

I've spent much of writing life focused on getting to the city's core. I've loved the challenge of exploring the unwieldy, unpunctuated sentence that is L.A. and I realized that the city wasn't just my mission but my muse. In that pursuit, I had found my writer's voice: So what had changed? And when?

My "there to here" story jumps back a generation. My parents came here to build futures beyond their imaginings. They caught the momentum of the Great Migration: My mother, who left New Orleans, was propelled by the beauty, "the orange groves, the hills;" my father, from Philadelphia, committed a map to memory that sped him across old highways—enticed by the notion of "elbow room." Their paths intersected. They had children. We lived in houses that looked like California dreams—Craftsman, Spanish stucco, Mid-century Modern. We, like so many others, saw the dream interrupted: riots and earthquakes, work derailments and health reversals. Detoured, we pressed on. I believed in their dreams—even the re-fashioned ones. I believed in their Los Angeles.

Ten years into a new millennium, I'd lost both of them in quick, disorienting succession. And with them went their goals and dreams—*their* city—my city—as backdrop. Only recently, have I been clear enough to consider the expanse of loss.

I t's strange feeling lost at home. You're not the stranger; the place is. A few months back, I finished an essay for a quarterly about streets and memory and Los Angeles. The germ of that piece took root in a journalism class I taught at Loyola Marymount University, called "Telling Los Angeles's Story. As I encouraged students to look beyond facile definitions, I found that I had to as well: My challenge was slightly different than theirs since I was teaching the class in the shadow of what home and place had once meant—and consequently means now.

My research launched me across the city's grid, drifting past old intersections and addresses. Nothing looked the same: Old domiciles reconfigured. New paint; new gardens; new sidewalk games. The dreamers and the dreams change. Los Angeles becomes someone else's canvas, a launching pad.

In retracing old streets, things clarified: I'd inherited a dream, not designed one. I'd hitched a ride. Like the angry dinner guest, I was waiting for the "it;" my silence, indicating my inertia.

Los Angeles is a place, not an incantation.

U gly?" I now can already hear myself saying the next time—because there will be one—my voice steady, clear: "No. Complicated. Messy. Takes work. Not handed to you." The beauty of L.A. is seated in change, adaptability. Like it, we too, must evolve; that epiphany, not a resolution, but a nudge of reassurance:

I'll locate my voice. I'll hit my rhythms. Pick up my pen. Turn the page.

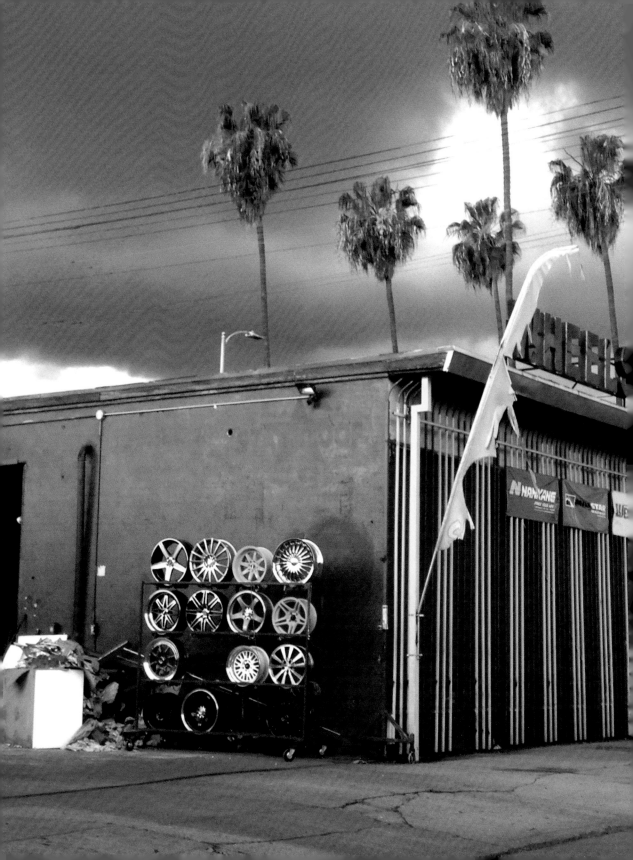

3 *Arteries of Memory*

DETOUR

I had been sailing along Martin Luther King Boulevard, making headway on erstwhile Santa Barbara Avenue when roadwork and orange cones diverted me onto a side street and into a remnant of my past. In the distance, largely unchanged, stood the high-rise where I once went for check-ups at my pediatrician's office. If I squinted, I could make out the bones of the hobby shop where my mother took my brother to buy his scale models of German panzer tanks and young Jack Kennedy's *P.T. 109*. But it was the cluster of slumped and faded storefronts rising from an expanse of cracked blacktop that took me aback. The once sleek, Jet-Age shopping center, formerly known as Santa Barbara Plaza, resembled an abandoned town after a massive toxic leak and, perhaps for good measure, an opportunistic earthquake.

Over the past several years, I'd only monitored the decay out of the corner of one eye as I sped past in my car. Occasionally, I'd skim over newspaper stories or half-listen to battles on the radio over redevelopment plans for the old shopping center, a shrill chorus replayed decade after decade. In the 1980s, Mayor Tom Bradley, with an eye toward expanding his list

of civic legacies, tried and failed to rebuild the square. In the 1990s, Mag-ic Johnson, deep in post-riot entrepreneurial mode, saw his plans for the site get bogged down in fights with city council members. Rumors came and went: a chain bookstore, a Trader Joe's, upscale bistros, mixed-use units. The square sat in limbo for years. Then, in 2007, the latest developer failed to pay contractors and set off a chain reaction of bankruptcy filings.

Just days before on a local radio station, I'd heard another heated de-bate between two candidates running for the local council seat, and the con-versation got stuck, like a skip in scratched vinyl: "But you weren't there. . .. But you weren't there. . .. But you weren't there. . .."

I *was* there, years ago and now again, on that familiar side street. I stopped the car on Marlton Avenue and stepped outside to take it all in. What happens when your memory lane leads to a ghost town?

In its prime, this self-described "modern shopping center" hummed with cheerful mom-and-pop operations—"high-fashion" boutiques, stationers, hair salons, travel agencies—and "plentiful parking." Some of the entrepreneurs had taken over older businesses and then proudly declared their establish-ments "Afro-American" or "black-owned," when those phrases held so much promise. Now the outdoor mall was densely draped in graffiti, its breezeways and mid-century architectural notes (flagstone storefronts, waffle dividers) blemished and broken. Potholes as deep as ponds dotted the parking lot; scavenger pigeons pecked at piled-high trash, molding shag carpeting left to the elements, a sofa sighing at the lot's center. A woman pushing a baby in a stroller sauntered the perimeter of the vast, oily puddle in the middle of the asphalt.

I stood there looking until I had enough. The wreckage seemed collected there in crumbled defeat. An unfinished jagged argument. Some windows still displayed faded and almost entirely transparent decals that taunted in the shadows: "Recycling Black Dollars." Across another building's storefront, hand-painted, fanciful cursive cajoled, Let's Do It Again, but in this context,

the sign's meaning was ambiguous.

What was it exactly that we were trying to build here? What were we to pass on?

The rubble at my feet, I realized, suggested something more complicated than politics or the cycle of urban blight. All over Los Angeles there are lost dreams like the one at Marlton and King. Dreams either elided or abandoned—often without hard feelings—in the name of progress.

What was the precise moment that this dream shifted?

SENSE OF DIRECTION

I seldom get turned around in Los Angeles, even with so many mutable landmarks that are here and then not. Long before I could see over a dashboard, I had to learn how to navigate the streets of L.A.

My mother, for all of her meticulousness, lacked a keen sense of direction. She knew it. Didn't fret much over it. But I did—enough for the both of us.

"We might have to start from scratch. . . ," she'd warn, steering the sleek black-and-silver Chrysler with its elaborate tailfins into the quick flow of Saturday-afternoon traffic.

She also improvised with time; it bent and stretched in her imagination. For a six-year-old who wanted in on Saturday afternoon ice cream and cake, and maybe a solid swing at a piñata at a school mate's birthday party, this was nothing less than ruinous.

"Hmm, left or right here?" We'd idle at a stoplight—she in a flirty neck scarf and huge, Italian wrap-around sunglasses, me in my gray-and-green "downtown skirt"—soon to be gently bumped off course and left driving in ever-larger circles, until we'd retrace our path as the sun changed position and color in the sky.

After too many meandering excursions, I began to memorize landmarks.

It was my way of taking charge. I *sensed* what east and west felt like, when we were tipped toward or against the correct direction. I could feel it in the drift of the car. And I could see it even with my limited view. The east meant more clutter, more signs and buildings to look at; in the west, the sky opened up.

I committed to memory how many turns it took to get to Crenshaw from our house on 61st Street near West Boulevard. Three: first a left, next a right onto Slauson where Teddy's Drive-In and its carhops commanded the corner, and then another left that would set us on track toward the Santa Monica Freeway.

"No, don't turn here, turn next time," I would say to my mother. Or, "I think it's the other way."

I certainly knew to keep my tone in check, because, as she would remind me, "You can't even see over the dashboard. You're about as big as a minute."

As I grew older, I learned the grid like so many L.A. adolescents, through a fair amount of watching. First in the backseat, then riding shotgun, later with a parent-designated "appropriate friend," and finally, during the clandestine drive through the city at night with someone who had access to car keys and lenient or otherwise preoccupied parents. We stayed off the main roads and began to construct our own maps, our own vision of the city.

THE SLAUSON CUTOFF

More than freeways, the east-west and north-south streets of Los Angeles—the arteries that connect the city end to end—unlock the city's narrative, how it segues and transitions from one style, thought, intention, declaration to the next. My father used to recite the names of major surface streets like liturgy: Main, First, Washington, Western, Sepulveda, Exposition, Adams . . . and, closer to home, Slauson. "Take the Slauson cut off," Johnny Carson used to say. "Get out of your car and cut off your Slauson."

I loved Slauson, even the very sound of its name, which referred not

only to the street that stretched from Santa Fe Springs to Culver City, but to a transportation hub, the Slauson Corridor. East of us, freight trains on their way to faraway places would roll over its zipper-like railroad spine like dinosaurs.

The street, namesake of land baron Jonathan Sayre Slauson, was home to plentiful put-food-on-the-table heavy industry and assembly-line jobs. That was until the decline of the area's manufacturing industry, which resulted in the shuttering of shops and the loss of jobs—many were never replaced, leaving grown men looking for solid labor and kids looking for after-school or summer work and, consequently, having too much time on their hands. Slauson became better known as one of those "border streets," the one ones that well into the 1970s delineated—or, perhaps better put, circumscribed—what became known officially as "Black L.A.": Slauson. . .Alameda. . . Washington. . . Main.

Back in our earliest days on 61st Street, our corner of Los Angeles wasn't called "South-Central" or "South L.A." We were " 'round Crenshaw." Or "just off West Boulevard" or "up the street from Hyde Park." We were also the first black family on that particular stretch—"blockbusters," as I later learned. This was the mid-1960s, so it didn't take long for the ripple effect to occur. In a half-blink, the neighborhood went from nearly all-white faces to a field of "For Sale" signs, which for a moment hosted a typical Los Angeles mix—Italian, Japanese, Mexican, black, and "Spanish." The designation "Spanish" (which really meant "Mexican") was claimed and understood with a discernible inner-hesitation that a six-year-old with a survivalist's nose for nuance could figure out. Like street navigation, I knew it was important by the way the grown-ups felt it necessary to specify such details, the precincts of self-definition.

We lived just about mid-block on West 61st, only a brief bike ride east, past the "Witch Tree" with strange whorls on its trunk that made it resemble a Grimm brothers' ghoul, to West Boulevard, where fast cars streaked

past and snatches of R&B playlists—"Cowboys to Girls," "Loveland"—spilled out of open windows. It's where my childhood kingdom abruptly ended. I wasn't allowed to travel past the big apartment building painted a color that matched my Crayola "flesh" crayon, but not the flesh of my own skin.

That little stretch of 61st, in that moment, could have been a filmmaker's backdrop for conveying the mirage of Los Angeles that existed in our collective imagination: white-stucco homes, built in the teens and twenties, with terracotta roofs and wrap-around porches, long driveways and yards that were a vivid sketchpad of shaggy palms and fruit trees and flower beds where the snapdragons fought for space amount the succulents. Paradise—until we found that it wasn't.

Watts, 1965, was like a dirty switchblade cut. It left a ragged scar that never quite healed. And though the bulk of the action transpiring over six days and nights of fires and military tanks and patrols of uniformed unsmiling men with rifles occurred many streets—even miles—away, the consequences of all of this moved through the city like a virus.

It seemed apt in a place that is ruled by its roads that a traffic stop ignited it all—when Highway Patrolman Lee Minikus flagged the young Marquette Frye on 116th near Avalon for erratic driving.

Not many years later, the big kids on my block, the ones who used to cast balls through driveway hoops with such a satisfying *swiiiiish*, weren't just poppin' wheelies by the Witch Tree. They, too, had begun to memorize a grid—a set of dividing lines that seemed then, and even now, arbitrary and random. New territories cut out of streets that had before been just neighborhoods. Now so many of these young men distinguished themselves in navy blue nylon jackets with orange lining, in starched denim with pressed four-inch cuffs, in canvas shoes with rubber soles. These neighborhood boys—one with a chipped tooth, another with a stutter, and still another with eyes of flecked sea-green marbles—had been the street protectors, but the question was, who would protect them?

In street parlance, they "got caught up" in gangs like the Rollin' 60s and carved out turf beyond this street, this neighborhood, this city, this state, this continent. We traded turf for what?

Those gangs were boys at first trying to protect what was theirs, I heard again and again from one self-described O.G. after another when, as a journalist, I started piecing together oral histories of my old neighborhood.

By the late 1980s, early 1990s, the Rollin' 60s became known as one of the largest (in number and territory) and most notorious street gangs in Los Angeles. Since 60th Street "rolled" through nearly thirty neighborhoods—from 48th Street to 75th and Western to Overhill—the name signified the sweep of territory as well as motion. Gang life drastically rewrote the neighborhood's story, and, as murder rates soared, it became one of the toxic elements that poisoned the dream at Santa Barbara Plaza and beyond.

But there was history and context, these O.G.'s would stress, almost too emphatically as they sat on floral-print or vinyl-slip-covered sofas, wearing corduroy slippers and sipping a cold beverage, happy to call themselves survivors and school me on what begat what and who begat whom, about territory and turf, chapter and verse. How the Slausons, an earlier iteration of black street gang, took its name from the thoroughfare connecting the easterly edges of Los Angeles almost to the sea and defended its neighborhoods from white gangs in Huntington Park and South Gate with unambiguous names like Spook Hunters. An eye for an eye, it seemed.

Our histories might be disjointed, but somehow the streets know the story; they hold echoes of the past.

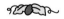

BACK TO THE CORNER

Anytime I circle the corner of 61st and West, a flood of sensations pushes through: the smell of exhaust off the boulevard; the wail of the old air-raid horn; the taste of sun-warmed plums shaken down from the tree, rinsed

in hose water; scratching my arms on succulents whenever I tried to pick a rose. I seldom turn the corner because I don't want to disrupt that memento.

Recently, though, I made the turn and stood on 61st in front of the old Witch Tree. I saw that the new owner of our old house had covered over the white stucco with a somber mud tone and cut the nearly floor-to-ceiling arched picture window in half, leaving what looked like a half moon. I was at my starting point.

I wandered down the street and found that the flesh-colored apartment building (now apricot) still holds down the corner of 61st. Long gone is the flower shop on West, where each year my father bought my mother a red-rose bouquet to mark the anniversary of their engagement; gone too, Humdinger, the place we'd go for burgers; and the "You Buy, We Fry" fish shacks that promised to bring "a little bit of the South" to Southern California. There's a Chinese fast food place where Teddy's stood, and down West a piece, Bob Marley's Smoke Shop has appeared. The streets that collectively intersect into something we call a neighborhood shape us as much as we shape it—and once we leave, it alters once more.

Cars still sail by, music still tumbles out of them—the oldies part of the sound collage is a surprising and comforting touchstone. Most telling were the young black men in sharp charcoal suits and red bow ties selling bean pies in pink boxes, joined by Latino men in elaborate straw *caballero* hats carefully packing colorful ices and fresh *fruta,* some dusted with a spray of cayenne pepper. Each of them passing the bounty from one hand to another.

There is a distinct, episodic quality to L.A. In smaller or differently arranged cities, pieces of the past are more visible, often integrated into your present—readily accessible as you plan your future. In Los Angeles, returning to a location out of your past, trying to re-experience a feeling that you had, can leave you dislodged and disoriented, depleted. No coverless and thumbed-to-ruin Thomas Brothers Street Guide or state-of-the-art GPS can take you back to where you used to be. In a blink that place you knew is not

just gone; you sometimes wonder if it was even there.

Just a couple of months after my detour back in time, the city sent a demolition team to finish off what the years had not at Marlton Square. Congresswoman Maxine Waters and City Councilman Bernard Parks were on hand just before the bulldozers cleared away the past to talk about the grand plan. "Let's Do it Again," I couldn't help thinking.

My street story then is full of odd avenues and boulevards beyond 61st Street—it's miles and miles of roads that don't always intersect but sometimes reveal some purpose.

That day back at the old Santa Barbara Plaza, I took one last look at the remains of the lost dream, then I got into my car and thought, this is what it is to grow up—and older—in a place where you can sail by your history, windows up, eyes on the next fork in the road as it shimmers in the seemingly endless horizon. You focus forward, eyes trained toward L.A.'s rewritable future. Let's do it again.

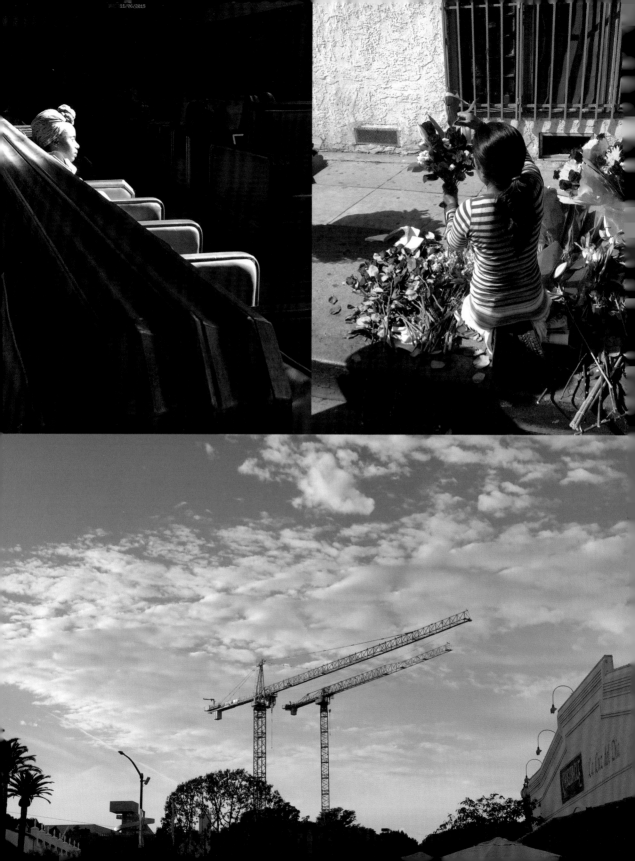

4 *For Now*

BY THE TIME I WAS eight years old, I yearned to drive a car. A longing that first, I'm certain, manifested itself as envy. My brother, Rocky, younger by two-and-a-half years, had been gifted a set of plastic car keys that looked authentic enough to covet. Some days, I'd abscond with them for part of the afternoon and mimic the "going out" motions my parents performed—patting pockets, checking "handbag"—before they stepped into the vastness beyond the heavy front door. Where I might go hadn't occurred to me. I just wanted to move—to explore.

Los Angeles had a particular scent back then, a residue that clung to my parents' clothes. Whenever they returned, I'd breathe it in when they held me close. Was it smog? Exhaust? The crumbling ozone? It registered as a worldliness that I wanted in on. That was 1971. It was also the same year when I first felt the earth pitch and roll—huge, wild, uncertain—beneath me. That quake (6.5; Sylmar) shook me awake in a way I couldn't quite describe for some time.

When I think about *that* Los Angeles, that big city rolling and unfurling beneath me, it felt both more vast and mysterious than it does now. Not just because I was a child, but because it simply *was*.

For natives of a certain age, the ground one walked on and the territory one passed through were seldom what they first seemed. Those fold-out

gas station maps we'd kept stuffed in the glove box, "in case," revealed little about the spaces that we, over time, dreamed of, occupied, then shed. "Turf" was something that didn't exist officially on a map, but rather in one's head. It needed to be negotiated, memorized, and updated frequently.

In the '70s, those words—*turf, territory, enclave*—circled through our language; they found their way into street slang, news reports, and family conversation. Power wrote and erased borders and dividing lines, and power—in politics or population—was always shifting. Those memorized maps provided an overlay—temporary, always fluid—to the official city grid. Truly knowing Los Angeles meant putting yourself into it, giving yourself over to it.

We moved only once in that span of a decade; in that time I lived in several distinct territories, both physical and of the mind. Los Angeles could be this way. Worlds unto themselves, side by side, veiled only by star jasmine hedges or hastily erected privacy fences. Mostly they were invisible dividing lines you'd come to know only if you stumbled across them.

The first streets I had begun to memorize—Arlington, Normandie, Denker, Florence, Hoover, 25th—shifted. For a time it was Hyde Park, Crenshaw, West Boulevard, South La Brea, Centinela. Later it would be Jefferson, Overland, Venice. Slauson, for all of its unglamorous heavy industry, the zipper of railroad ties, I realize now was the only familiar and dependable through-line linking those many chapters.

I started school with almost all black classmates. For a time, predominately white. Then black, and by the end, tipping toward mixed again.

Over that time, through all of those transformations, I always resisted—no, bristled at—the term "melting pot." It sounded like a cartoon cauldron. Relatedly, in the '70s, each time I heard the term "white flight" floating out from the TV, I imagined a set of wings—not the entire bird, just one detached span of wings. Floating.

At any given time, some groups were fleeing as others were arriving. It was about the time that I realized that there were "many" Los Angeleses

swarming, each with stories that tended to remain in the margins, territories that could only be accessed by someone familiar with its history and layout. So many neighborhoods seemed to have holdovers—that house in the center of the block whose owners refused to budge, who still put their laundry on the line and had actual blue-glass bottles planted in the garden to ward off bad spirits. The hope was that that "place-holder" ensured that what *had been* before informed what it would be.

What I saw on television or in the movies didn't jibe with what I encountered daily, no matter where I lived. The black L.A. where I grew up in the '70s, was a territory built of dreams and defeats. A work-in-progress that was still being shaped by the unrest of the '60s and the outsized dreams of our forebears. Impatience and disappointment created a generational dissonance that played out differently on this turf—from block to block.

My family was tugged by its own particular counter-melody: In the early '50s, my parents, who had yet to cross paths, migrated to Los Angeles from different spots on the map. My father from the East; my mother from the South. Their specific experiences—Southern, de jure segregation versus Northern de facto—provided distinctive prisms for addressing the present and anticipating the future. Their notion of "more" was determined and calibrated by what their access had been.

They both travelled here for "opportunity." I see it in their smiles in the deckle-edged snapshots from that time. That sense of optimism lingers in their expressions in images from later in the decade, by which point by now they'd learned that that word—opportunity—which *felt* expansive, took on a different shade of meaning here. Despite it all, within those enclaves, they created communities. They created emotional safety nets. They created a big world—study groups, community organizing, social clubs, Pokeno nights—in those narrow margins.

If segregation in Los Angeles didn't resemble its counterpart in other cities—restrictive housing covenants, whispered demarcations—so, too, would integration. In the '70s, the same year of that earthquake that rocked me, we moved to a house with a wide view of the city. A cinematic establishing shot on the Southeast edge of Culver City. There, I began to get a different lay of the land.

A new neighbor, an archaeologist, with whom my mother had struck up friendly driveway conversations, brought over a fossil in a plastic box as a gift for my brother, who had been showing interest in history and science. She also brought with her stories of cross burnings in the hills just west of where our house stood, violent incidents marking territory not so long ago. My parents had been tipped off. We'd purchased our home from a Jewish couple. They'd sat with my parents on the half-circle olive-green sofa negotiating a plan: It was suggested that we keep the sign up on the lawn until we'd moved in, to keep questions to a minimum. They'd had "a time coming in" themselves, they'd confided to my parents. It was familiar territory. This would be the second time in my young lifetime that a household move would involve an intricate plan and a surreptitious arrival.

In the weeks leading up to moving day, I had been consumed with reading and re-reading *Mary Jane*, one of those books you'd order at school that would arrive in a stack with a rubber band cinched around it. The novel was about a black girl who was integrating a white school in some unnamed city. In the cover illustration she had a ponytail like mine, tied tight and high with a red ribbon. I have no memory of the plot turns, just her face and how set apart she appeared on the cover.

I began to obsess quietly about students carving *epithets* on my wooden desk. "Epithets" was one of the words my eye kept landing on in stories I'd been reading about the era and the Civil Rights Movement in particular. That word sounded more dire than whatever specific invective might be hurled my way. I wanted to know everything that was possible about crossing lines.

I viewed my new environment in the context of the not-too-distant past. It was difficult not to. With Boston and its operatic busing crisis erupting on the TV nightly, it still very much seemed to be part of the present. People were holding the line, securing their territory. Not braving, but enacting violence to do so. How could *skin,* and proximity to it, be so terrifying?

Our old block had seemed to me an idyll—aprons of green lawns, bountiful shade and fruit trees, small, a row of single-family homes—but much later I understood that we were living in the heart of the Rollin' 60s Crips territory. Gang turf. These streets I knew. They were streets I skated and biked and lingered on past sundown. It seemed beyond imagination that something bad could happen, but that's what folks from out of town always used to say: "Where are the bad parts? Have we gotten to the bad part yet?"

I would repeat, for decades, "Inside, it's different."

In response to the moment, I watched my older male cousins' hair bloom from brushed-back waves into beautifully shaped spheres. Crowns. Six-foot four and six-foot five, they were royalty at L.A. High. At home, they were soft-spoken, pulled out chairs, walked on the outside of the sidewalk. Sunday dinners in Chinatown to accommodate family and extended family ringed around an enormous Lazy Susan. Outside of their familiar blocks—our territory—they were seen as "radical" or "angry." I wondered at the use of that word: Did radical mean that you liked to read, that you looked people in the eye? That you knew your history and spoke your mind, as they did? Context, I would learn, in the '70s, was everything.

In the early '70s, I sometimes slept with a transistor radio under my pillow. My mother, a teacher, did so too. I found music, Motown and Stax and Philadelphia International, other-city sounds that opened up vistas. My

mother was transfixed by news and talk radio. Headlines and talking points she'd weave into classroom lectures. The destabilizing pitch and roll was happening across the country; it was re-imagining the notion and composition of neighborhoods. As with Boston, Los Angeles schools were just beginning a round of mandatory busing, but unlike Boston, it wasn't so much violent as it was dislocating. There was a current of worry. I recently found a diary entry of my mother's from that time: "Went to Area Integration Mtg w/ team. Stopped at Kaiser Emergency. Blood pressure was up 170/108."

In my new neighborhood, first day of school, no one carved any epithets on my desk. I was relieved. But at recess, the neighborhood girls with the butter-colored hair would play "horse." This required that the participants get on all fours in the grassy area and crawl around and neigh. There were four or five other black girls in my class that year. A couple of them crawled around too. I watched for awhile, then drifted away. I couldn't imagine coming home with grass stains on my white knee socks and having to explain why. "You let someone do *what*?" It would be one of the first lines I drew, one border I would not cross.

I longed for my "geometric gym" of our old all-asphalt playground at 48th and Wilton, hearing the over-the-fence fender-benders, muffler shop's alley-laughter, and window-sill radios tuned to Sly and the glittered-up Family singing: "Everyday People." Some days we'd replay scenes from last night's episode of *Mod Squad*. Heads or tails: *Who gets to be Linq with the righteous 'fro?* I missed that old air-raid horn from the old neighborhood, even then a relic. The danger it was there to warn us of had evaporated. We were now more concentrated on the danger at home.

From time to time, we'd circle back to the old neighborhood for church. Or when my parents had plans to be out for the evening. They trusted only family or friends of family to watch us. That meant a trip back through those old memorized streets, a recitation of names I'd perform aloud. Our babysitter wore gloves—kid or cotton depending the season—when she got behind

the wheel to ferry us, even if it was just to make a quick stop at one of the few markets still left in the neighborhood after the riots of '65. Her house was a neat white-and-yellow bungalow, run-through with wall-to-wall shag carpeting that was a shocking shade of Christmas cranberries**.** Her husband was always dozing, drifting in a big leather La-Z-Boy. A cutout in his slipper revealed an open sore near his heel that never seemed to heal. She cared for him with a warmth and efficiency that propped up his dignity. If she was worried or sad, she didn't reveal it, that pain, perhaps located in some zone, blocked off, deep inside her. This was time slowed down, protected. I can still smell the teacakes baking in the oven and the sweetness of the south that had come here to South Los Angeles. But we didn't call it that then. We just called it "home."

And a tangible sense of home was necessary whenever some destabilizing affront would occur, like the welcome-week salvo I had in our neighborhood park when a little girl I was playing with informed me, without prompting, that she was smarter because she was white and I was not. Or the time my sixth grade teacher in my new school pulled me aside to tell me that she wasn't happy with a poem I'd written because it was "too angry." But she didn't phrase it that way; instead she framed her distaste thusly: "*Dr. King* wouldn't like it," spoken in a tone that should have shamed me for life.

Like our parents, we were creating and charting our own worlds. Hierarchies came with them, too, as it happens. They had to. Rumor was winding around that one classmate's mother was dating a temptation. It sounded like a poem to my ear. I knew better. Of course, she was dating a *Temptation*. One of the singers, from one of the many iterations of the group. Sometimes, while waiting for the bus to carry us to school, we could catch a glimpse of him—Afro, flared pants, and platform shoes—standing in front of some shiny long-stretch-of-a-sedan in the driveway. It gave an already-popular girl *Teen* magazine status.

In these moments, what I began to translate was that turf and territory

weren't simply about race; rather, the place to which one was condemned or elevated was also bound up in status. Again, hierarchies. If you were impatient, you could force a crossing in creative or canny ways. One Monday morning, one of my closest friends arrived at school and announced that she had gone to see *The Exorcist*. Masses, it seemed, crowded around her. Gaining access to anything outside the confines of our neighborhood's closely-knit network of Lanes, Courts, Ways, and Terraces registered as seismic. *The Exorcist*'s run at the National Theater in Westwood had been an event for weeks. People camped out on sidewalks. Lines looped around the block. Even full-page ads in the newspaper fanned at the phenomenon.

Her parents, like mine, were protective; they tended to keep a short leash. They were religious—Black Southern Baptists—so I couldn't imagine that she'd be greenlighted to see an R-rated movie that essentially handed Satan a starring role. I didn't believe her. It set my stomach in a spin that my friend had told me something that I knew to be patently untrue. I felt something move inside, sever. I knew she wanted to fit in with the other, older-appearing girls. I knew she wanted to cross over a line and into territory it would take me a decade or more to even understand, a blasé, L.A. sophistication. Moving outside of those borders lent her gravitas, worldliness. Now I understood the idea and power of spectacle as only Los Angeles could play it.

Still, I wanted to match her, to claim my own place on her turf, despite its dubious form. I begged, but my mother wouldn't allow it. I sat mesmerized by TV news reports about the pandemonium that now seemed to take place nightly. It was reported with a sensationalism and frequency that suggested a natural disaster. Protesters with placards and rosaries lined Lindbrook Drive. Grown men fainted. Audience members threw up in the aisles. I begged some more, to no avail.

I knew not to push it. My down-the-street neighbor—part Mexican-American, part black—was in the same boat. Her father had also issued a non-negotiable "no—you are far from grown." Our borders were firmly in place. We'd

groused about it over homework one afternoon with her father in the background. By now he was fed up with the histrionics on the TV screen, the daily reporting stand-ups from in front of the theaters. "Foolishness!" he muttered to his wife. "You see? That's why they didn't want us too close. We'd see a little bit too much." As quickly as his appraisal greeted air, I could see the regret pass over his face. He'd forgotten my presence, an extra set of ears that weren't within the family's. He apologized, then picked up another thread of conversation, as we were all supposed to be integrating nicely without much editorializing from the grown folks. No matter; I knew, we were deep into the wilderness by now.

<p style="text-align:center">✦</p>

I began junior high with boys named Keith, Kevin, and Kenyatta. By high school, I knew an Aristides, Imtiaz, and Ephrahim. Our campus breezeways buzzed with an intricate lacework of foreign languages, strategically unleashed in the presence of teachers, narcs, or anyone who should be viewed cautiously. It was a moment to test and usurp boundaries, to shift power. My Persian and Arab friends struggled under the weekly headlines of the gas crisis and images of the Ayatollah Khomeini staring back at us all with stormy eyes in dinnertime newsclips. Sometime around then, the city's department of transit abruptly halted the bus service that loped up into our neighborhood. The bus driver claimed he was afraid of us. *Us*. It took a contingent of parents doing double-shifts of carpool duty and city council meetings to reinstate our branch of service on the line. No, we weren't *melting*. We were bumping around for some sort of way to be.

Between the end of junior high and the beginning of high school, I became obsessed with a boy named Erick. Even if there were seats, he always chose to stand in the middle of the aisle of our morning bus and not hold the onto the rail above. Essentially, he would "surf" curves that the bus took as it wended its way to our school. It took me months, maybe years, to realize

that it wasn't a crush I'd had, but rather an obsession, to watch this Mexican American boy—with liquid brown eyes and "Jesus hair," as one of my bus-mates put it—defy what box anyone chose to put in him. His OP cords and two-toned, purposely mismatched Vans moved him out of easy categories into which anyone might foolishly try to place him. He seemed to run with no one. No fixed crew, clique, or tribe. He seemed to float above their territories.

As they do, lines that seemed indelible eventually wear or sometimes even wash away.

We had seasons of rain back then. Flooding. In 1977, my schoolmates watched Ballona Creek rise higher and higher. There was a line painted on a paved creek wall. Campus lore had it that both the junior and senior school campuses would be dismissed if the water crawled above it. One magical morning it did. Teachers rushed us home under a bruised sky. I couldn't remember being set free to explore. Ad hoc carpools were set up to ferry home those of us who had working parents. I got into a car of an upperclassman neighbor, a Japanese American boy who was remote, but not unfriendly. I'd seen him daily, but we'd never exchanged more than a couple of sentences. Maybe his silence was simply about brokering distance, creating a space for reinvention. Was he embarrassed about those streets of which I was so proud? I wouldn't ever come to know. That day, instead of taking the most direct route, he chose a longer way home—Sepulveda to Slauson, looping back to La Cienega, then Stocker, which edged past the old oil wells. We rode in silence in the rain for some time, emboldened by this freedom, time that could be left unaccounted to roam.

I knew by now I needed to draw maps of my own. Summer school, I enrolled in driver's training. The car that we were assigned to always smelled faintly of weed. My driver's training teacher wore his blue-black hair hanging free, falling just past his collar. His eyes matched the color of the aqua windbreaker I'd seldom seen him without, no matter the season. He was easy

to talk to in a way that was comforting and yet not over-the-line creepy. I shared the car with two boys, Jeff and Rob. Surfers. Not part of a tribe, just devout "water babies." The four of us would slide into our seats early in the morning, heading south along the s-curves of Sepulveda Boulevard. Some mornings were so socked in by fog that it added extra intrigue to our journey. Our instructor always referred to the sleepy suburb of El Segundo—where we did most of our street driving—as El Stinko, because of all the industry chugging away nearby. "We'll know when we get there!" I never went to El Segundo with my family; someone told me years later that they thought it was a sundown town—a segregated city where people of color were aggressively, often violently, kept out of their boundaries, especially after sunset. I'd never heard that confirmed. But Culver City was indeed one.

I wish I could better remember the constellation of protected places. The rise of walls on the junior high school quad. The area off to the side of the portable classrooms near the playing fields. There was a nook, somewhere in front of the high school, where one of the car clubs (Cuban?) would collect before school. That spot where the surfers would congregate after the beach, just as first period was ending. Constant assessing: *Which lunch table could you sit at? Which one should you avoid at all costs?* All of it vague or gone now. But all of this was so essential to know, to commit to memory. It took up so much brain space. The whole campus was marked with invisible designations, places you were not to cross, pause, sit, or stand for fear of repercussion. Long after the bus driver expressed his fears, the Crips made their way to campus, too. Boys stepped on the bus in puffy blue jackets with orange lining. The last row of seats was left open expressly for them. By then, most times, we had a black driver.

Some weekends, the grownups' conversation around the garage bar at my new junior high school friend's home tended toward bawdy. The jokes snaked with innuendo as the adults leaned over card games of risk. Her father's friends were studio craft guys—carpenters, gaffers, prop men and

women, etc. All white. Most were polite, some even friendly, but there was always one. Just one. He'd sidle up and let it drop: "There was a club on Jefferson, in Culver City, called the Plantation." Not quite a statement, not quite an open question either. "Your family? Where'd they come from, Watts?" Hostile? Certainly. I knew to look him in the eye, as if to say, "I see you. I do." Such focused resentment in his prodding. Though he never arrived to the point, I knew precisely where he was headed. He was put off by having to share personal, sacred space . . . with *me*. Finally, I explained to my new friend that I would no longer be stopping by if he was ever part of the mix. She never told me if she'd mentioned my line in the sand to her parents, but shortly thereafter, Rob vanished.

I'd won.

But what, exactly?

I put my hands in masa for the very first time during a Christmas season in the late '70s. I listened to instruction about how much to spoon onto the cornhusk and how to arrange the delicate package in the pot for steaming so as not to harm it. My friend Rita's grandmother was leading us through this journey, but she was speaking carefully, dotingly, in Spanish. Later, I understood that I had begun to comprehend more than I realized, the result of proximity and will. This is how so much came to us if we allowed it to happen, were open to it. While we marked our turf in language, in clothing, through slang, we moved in and out of circles, taking pieces of the old with us, making something new. I used to think we found common ground, but no, better; we made common ground when need be.

By seventeen, I'd failed my driving test twice. News I shared with no one. In Los Angeles, this ignominy was almost worse than being held back a grade. So as not to feel so marooned heading into my senior year, I bussed it or cadged rides from friends in their Pintos, Corollas, and Fairlanes. It was 1979.

College lurked, and I was still eleventh-hour practicing; my father's urgent directives to "Cover the brake!" ratcheting up my nerves. Third time was a miracle. And though I'd botched the three-point turn, the test administrator showed mercy. Maybe he had once been me. Perhaps knew what it was like to be just so close to being independent, to moving into and defining your own your space.

Back then, after nightfall in some parts of the city, the air was redolent of the ocean—sharp, brackish, and vivid—even if you were miles away. That scent traveled like radio signals did at night—beyond specific borders. I always took that phenomenon to mean that all of Los Angeles was ours if we could reach it, unlock it. That evening of my triumph, the first place I drove to on my own was the ocean. Out to the very edges of discernible land. This strip of unremarkable beach had no associations, no history for me. It wasn't a touchstone. And that, I learned, was immeasurably powerful. It was the first pin on a new map.

It's dangerous to deal in nostalgia. Especially here. Change is rapid, and it's seldom kind. Though I know this, sometimes the awareness alone doesn't keep me from trespassing territories of time. This all sailed back recently when road work forced me off the freeway three exits too soon.

Because I had some time to spare, I made a detour to the detour. Pulled by some old strain of wistfulness, I wanted to loop, if briefly, through those old memorized streets—the places, fought for, the places we'd always called home. I parked and, moments out of the car, found myself at a dead stop in front of a house. An old neighbor's stately California Craftsman now painted charcoal gray with a chartreuse door, the planks of its privacy fence turned horizontal. History turned on its head.

My thoughts came fast, but were tripped up by movement in a neighboring yard. I saw just the top of a man's watch cap and a plaid shirt. I heard the

blade of a tool he was using to chop away at a tangle of morning glories. A gardener? My eye moved back to the cartoon house across the away. So sad. Who would do this? Why?

Before I spun too far into my questions, my protestations were interrupted by a sneeze. "Bless you," I said reflexively, turning into the sound. The man in the watch cap looked up. No. Not the gardener: He was my age, graying around the temples, his eyes the same color as my driving teacher's windbreaker. It wasn't a plaid shirt he was wearing, but a bathrobe, hastily tied, his coffee cup balanced on a weathered fence post. He was not on the job. He was home.

"I'm sorry," he said gently. "Did I startle you?"

"No," I responded. Quickly. The crispness in my voice surprised me.

But really, was that true?

He *had* startled me. But not for the reasons for which he was apologizing.

What did it mean for me to feel startled, to be so tangled in the push/pull of emotions that it was simpler, but certainly not easier? To lie?

I lingered on the sidewalk for an extended moment, not just without words, but disoriented. Uncertain.

An old sensation passed through me, a feeling linked to childhood: My body being pulled and released by the ocean, and how the echo of that sensation would linger for hours, well into the evening, even as I was settling down to sleep. The pull and release of something far bigger than me, was what was pushing through me.

This acquiring and ceding territory, it's the same to be caught up in motion that never ceases—a tide that drags in, drags out. Lines etched and erased with time. It keeps you uncertain. It whispers: *For now, not for always.*

From where I stand this spring morning, this place—the territory that has most felt like home—is still not so fully transformed that I can't feel its old rhythms, breathe in its familiar scents. But how much longer can I call it mine? Maybe it never really was. Like Erick on the bus, maybe I've always

floated over it. Ridden its curves.

Place is tangible—navigable, yes—but place is also time. Moments collected and protected: That late-night radio transmission, that air-raid horn, that blue-bottle garden, the fierceness of a hug—that's part of me. All those points leading from here to there. It's deep inside. And that's the territory that most matters. That's territory that can't be mapped, breached, renamed—or erased.

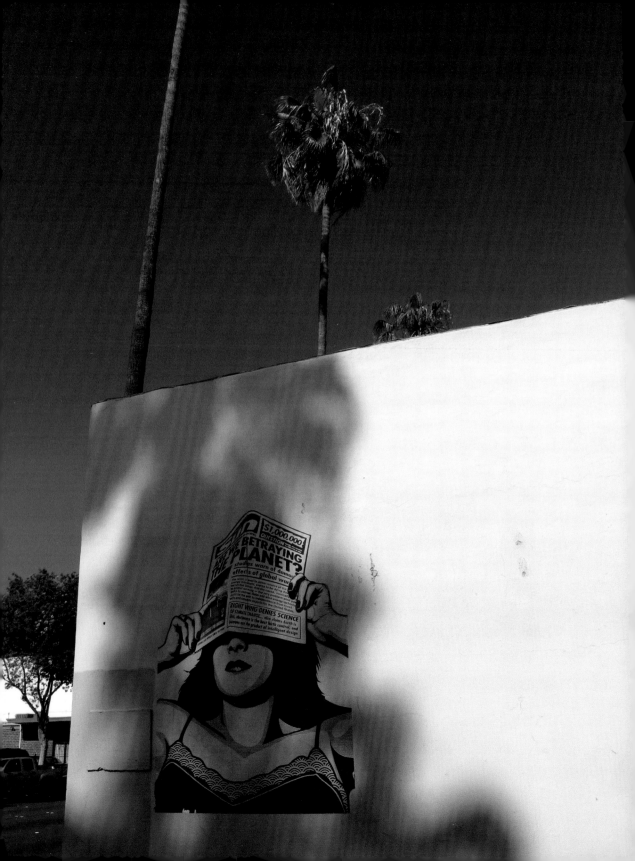

5 *The Language of Memory and Place*

NAVIGATING LIFE IN LOS ANGELES is mostly a matter of interpretation. Those "seventy-two suburbs in search of a city" that Dorothy Parker so indelibly defined and dismissed in one quick laceration is one way to characterize Los Angeles and its meandering sprawl, and a roots-deep Angeleno might read the Parker analysis not as insult but elucidation. That difficult-to-pinpoint character is what makes many die-hard Angelenos stick it out, despite the perpetual swirl of bad press that surrounds L.A. Some see their city as episodic, others as a series of situational non-sequiturs. You can't sum up Los Angeles in a sentence; it always demands a deeper look.

It isn't easy to jackhammer through L.A.'s glossy surface-story, the beamed-to-the world simulacrum the world thinks it knows because they've seen it on TV. Yet Lynn Garrett is attempting to do just that. She didn't just step into the fray but in a sense created one, a necessary forum of her own design—a place to explore and talk about the city without qualification or apology. Her lively blog and website, Hidden Los Angeles, along with its corresponding Facebook page (more than 300,000 followers strong) is dedicated to the daily endeavor of "going deeper"—in a city where people often interpret the very word "deep" as spurious: an oxymoron or the lead-in for a late-night comedian's joke. To Garrett, Los Angeles has always been a serious subject for analysis and a constant source of surprise.

"Oftentimes, when people come to Los Angeles, they really don't see it," she observes. "They think they have a solid, informed opinion of it. Even though they only stayed one night. At a hotel. At the airport. What on earth would you learn about any city that way?"

Since 2009, Hidden Los Angeles has presided over a lively twenty-four-hour virtual town square—linking current city-dwellers and expat, multi-generational natives to the casually curious from around the globe, feeding them into conversational threads that explore both place and perception in L.A.'s past, present, and future.

Part old-school news editor and part twenty-first-century content curator, Garrett single-handedly offers a regular flow of informational/conversation-prompting posts—video, photographs, news links—that fold in breaking news, history, cultural studies, recreation, city planning, conservancy, and nature/ecology. She has transported a famously elusive city into a virtual place, and attempted to give it shape and form.

Over three decades (on and off) kicking around Los Angeles, Garrett, an accomplished artist and graphic designer, has worked variously as a jazz singer and tour guide, for Disney Consumer Products as a senior designer of toy packaging, and for a time, as a senior art director at Mattel, where she designed board games. You see a little bit of all of those incarnations in the range of content explored on Hidden Los Angeles—in the online environment she's created and the improvisational flow of ideas that dovetail to the next big thought.

Taken as a whole, Hidden Los Angeles is a fully interactive community —a virtual tour/online magazine of the city. It doesn't ignore Hollywood as an industry but puts it in the context of the rest of Los Angeles—its ethnic communities, its flora and fauna, the curious factoids about L.A. in its earlier incarnation (a "horizontal" city, suburban sprawl, the old skyscraper limits)— in other words, what it really means to live here.

The real city, Angelenos know, blooms along the edges of outsiders'

perceptions of it. What might appear arbitrary is actually the many chambers of its complex, working heart and how it fits into the world. That was the big question Garrett asked herself when she began her inquiries.

Part of really *seeing* Los Angeles, she has learned, is a simple act of shifting one's perspective. "When we go to visit other places, we seek out and are often attracted to the cultural things. The history. It's as if we have different expectations for Los Angeles."

That's been the case since its inception. The city was often seen as an antidote: a cure for the body and soul; a site of reinvention, a launching pad for dreams. Its own story—its indigenous riches, how it came to be, who shaped it—took second billing. For frequent visitors, the city is a palimpsest upon which to write their own story. "People think the past is gone," says Garrett, "but it's around every corner—it's there, and so is meaning."

Native Angelenos traverse space with double vision: seeing both what is here and what is no longer. We hold two cities—and two ways of navigating that past and present place—in our heads. Each generation finds different touchstones to define itself and create connections over distance and time. An Angeleno growing up in the '50s or '60s carries a different set of vivid sense memories (the scent of orange groves in the evening say, or a day trip to the valley to explore the strawberry fields) from one who grew up in the '70s (the jagged surrealscape of ruins of Pacific Ocean Park). All of those reference points are now mere vapor, the stuff of souvenir View Master discs and collectible floaty-pens. Yet there too is common ground across generations—light or vistas or the blind, thrill-ride curve of an onramp lifting into nothing; the fine details, however, might be a shade different. Getting to *this* Los Angeles and reanimating it takes a unique sort of resourceful patience, and enthusiasm.

Excavating this tangible sense of place in a virtual world means that, in the day-to-day, Garrett is a bit of the ringmaster overseeing layers of fervent back-and-forth opinions and assessments, first-person recollections and

sometimes virtual filibusters in real-time. Ostensibly, her hours stretch from dawn to dusk—but often in the wee hours you might catch her logging on to set a thread of conversation back on track. "I just have to be really careful that people aren't using the site to promote themselves," she says, pausing to acknowledge one of the truest clichés about L.A. "Yeah, we've got a lot of self-promoters here. I wanted it to be *about* Los Angeles, *not* a giant press release."

Garrett has for years mediated much of the content from home via the various keyboards and handhelds strewn across her dining room table or tossed into her handbag. The online wordplay of her vast online community has an arc of its own; it's sometimes shrill, sometimes snarky. It's often passionate and frequently playful. But all of it—even in its polarizing disagreements—is an attempt to get beyond the easy clichés and assumptions about Los Angeles.

What might Hidden Los Angeles feel like to a first-time visitor? Well, imagine having several thousand highly opinionated Angelenos sitting at *your* dinner table—often talking all at once—sometimes informed, sometimes not so much—but no matter; they discourse with authority about L.A. history, the L.A. River, the best east/west routes, downtown gentrification, the Valley's old strawberry farms, childhood earthquake memories, riots (both of them), the Olympics, the elusive borders of neighborhoods—and quite often, one of longtime Angelenos' favorite topics—which lost architectural treasure (probably rebuilt many times over) stood at the corner of some long-vanished intersection.

What's striking about the ebb and flow of conversation—even exchanges that evolve into tangents become contentious—is the realization that so many Angelenos feel the need to find a forum to discuss what's gone, what matters, what's changed, and why. The nostalgia trip is only a small part of what a visit to Hidden L.A. offers: the exchanges reinforce a sense of community when so much of L.A. shifts underfoot. Sometimes if you're homesick, "lurking" in

a virtual "room" with people who understand the idiosyncrasies of living in a place as fluid and shape-shifting as Los Angeles, is tonic enough. What she provided, that hadn't existed before in quite the real-time way, was to create a form that spanned time and place. For me, and other Angelenos who had been convening these off-stage discussions about the changing sense of place, it was a place to engage passionately about the city where you didn't have to explain the hows and whys of Los Angeles, where you didn't have to constantly defend it—which allowed, at moments, for different pathways of memory. For my friends who tune in from afar, having long lived away: "It's a good trip home."

Even still, given the vast spectrum of strongly held opinions about the city, what keeps Hidden Los Angeles from swerving into the thicket of troll-infested shock talk—all noise and emotion but no grist—is Garrett's quick, decisive, and hands-on facilitation. Hidden Los Angeles has a guiding voice and point of view, and it is fully Garrett's. She can keep conversation aloft like a vigorous match of volleyball, but knows when to spike and shut it down if it's edging toward nasty. ("Just this morning," she says, "I had to tell a guy to stop being a 'dick'—he was just making rude remarks about other members.") She's quick to right some toppled bit of logic or break up heated exchanges edging toward virtual fisticuffs. "I don't like to, but I ban people if they get too out of hand," she admits. "But every year I do a 'turkey pardon' and give them another chance. This is for them. They need to be respectful of others and their opinions." In many ways, what Garrett has mapped isn't simply a website, but a milieu, an online replica of those seventy-two suburbs—a distinct "neighborhood" unto itself.

We walk into the stark white light of an August afternoon—the first break in a three-week, three-digit heat wave. Garrett has agreed to walk away from the screen (one smartphone in her bucket bag, just in case) to let her community "talk among themselves." Though sometimes it's difficult for logistical reasons to do so, getting out is precisely what she prescribes to her followers.

In fact, she encourages people to move out into the world. She's been hosting meet-ups under the Hidden Los Angeles banner almost since the site's inception—cocktails at the venerable Musso & Frank, late grunion runs, kayaking the L.A. River. She launched a series of participatory philanthropic events, working with Downtown's Los Angeles Mission and the Hollywood-based My Friend's Place, focused on assisting homeless teens—as a way for the community to experience one another as well as Greater Los Angeles.

<p align="center">✳</p>

It's a postcard day in a neighborhood studded with tall, listing palm trees and a handsome collection of 1920s stucco and red-tile duplexes. Picking one of the main thoroughfares, she moves with the purposefulness of a seasoned tour guide—two steps and pivot, to explain the terrain before us: past the posh boutiques on 3rd Street, Mid-City, scouting for a coffee and a quiet chat. Despite her L.A. Doyenne status, she's dressed casually in a pair of jeans and a simple, black, v-neck t-shirt. Garrett points out the French place and the Greek place and the Spanish place and the neo-all-American-diner place. And all of those languages drift out of open doorways and swirl above the small sidewalk patios—packed even in the pause between breakfast and lunch. She settles on the French place, where the ceiling is painted a vivid cobalt, and the waiter knows her well enough to ask her only to specify her drink's size. "You can find a little bit of everything you want here, depending on your desire or mood," she says, "but that's the key. You have to look for it."

A native Californian, born in San Diego, Lynn Garrett spent a lion's share of her early life in Los Angeles. She lived for a time with her maternal grandparents and grew to love L.A. through their eyes. "When you're from San Diego, the default is to hate Los Angeles. But I had history here. My great-grandfather and grandfather painted murals at Charlie Chaplin's house and at Pickfair [Douglas Fairbanks and Mary Pickford's mansion]. My grandmother, when she was nineteen, preached with [the evangelist] Aimee

Semple McPherson, and used to babysit her kid. My grandma Beulah. So I had a huge family in L.A." Consequently, she interacts with the city like a native, finding pieces of her past; everywhere a vivid sense memory—an old traffic light on Sunset Boulevard or the postcards on spinner-racks at Farmers Market—just around the corner.

Her appreciation grew even stronger as she began to navigate the neighborhoods on her own and without a plan or map. Eventually, for a time in the 1980s, she put down roots here and began to map her own personal version of the city. She let serendipity lead her: "I'd fill my tank with gas and just drive around." No destination in mind. She'd let herself be pulled by whim or the itch of curiosity. But truly finding her heart connected to the city was a more complex affair; it didn't happen overnight.

By the '90s, burned out on L.A. in its post-riot, post-earthquake, post-O.J. Simpson murder trial period, she picked up and moved for work to San Francisco. But there she was struck by the persistent chorus of anti-L.A. sentiment. "It just seemed like a one-sided conversation," she recalls. She found herself routinely defending Los Angeles. Her San Francisco acquaintances recommended that she needed to get a sense of humor, "but instead I started writing all the things down that people hated about L.A."

It got so bad that for expedience and sanity's sake, she began to keep her origins and alliances close to the vest. She believed you should be allowed to be proud of where you come from. And so, her thinking was, "If you don't like it, change it." Not the place, but the conversation around it.

That list in hand, she returned to Los Angeles with an idea to write a tour book—one targeted at the people who think they don't like L.A. The guide would focus specifically on L.A. as a culture, what makes it move—the art, the literature, architecture, the distinct neighborhoods. To get herself into the writing rhythm, she designed a blog to help work out theme, tone, and voice. A friend suggested Facebook as a way to promote the blog, to which Garrett recalls responding, "I'm not thirteen. I don't need to be on Facebook."

But the social networking site would change everything. People clicked on, clicked through. Told friends. Conversed.

As it turned out, *lots* of Angelenos felt the way she did. In the spring of 2010, her fan page went viral, spiking to 137,000 pairs of eyes from three thousand in four weeks. "Once you get over sixty thousand members, it's like having a monster in your garage," she says, a little ruefully. "No one else has a monster in their garage, so there's no one to talk to about it. And there's no book to tell you how to do it. I had to figure it out." And while Garrett would like to also "figure out" a way to monetize the site and hire a full-time staff, she wants to do it in a way that makes sense and is in the spirit of the site and its goals.

For a virtual place, Hidden Los Angeles has done a real service. In a subtle yet indelible way, it attests that our sprawling, anonymous city isn't always so. "I've watched the craziest, random things happen online," she says. "I might post a picture of some event or place from thirty, forty, fifty years ago and suddenly people are tagging one another and [these people]—who haven't seen each other in years—begin having a reunion online."

In this respect, Garrett sees the site as a corrective and a colloquium that allows the city's story to be shaped from the ground up by residents who actually experience it. A flowing, people's history. And the interesting thing, she says, is that "forty percent of the people who are on Hidden L.A. don't live here. Some of them used to, some of them are curious about visiting, so they begin to get a sense of what it is by watching the posts. Some of them have been in the military serving in both Iraq and Afghanistan. So many of them come here when they are feeling homesick and they want a dose of home. Something I really wanted when I lived away."

While reminiscing is key to her page's allure and success (other L.A. pages—like Vintage Los Angeles or Who Remembers in East L.A.? have grown up in the short time she has been in operation), Garrett is committed to a mix that isn't just a series of backward glances. She wants Angelenos to

get up and go out and experience their city—so that the places and events that we enjoy now don't go the way of the vanished mom-and-pop shops we so romanticize. These conversations reveal the layers, the many cities Los Angeles has been over time, and what has been built on top of them.

To really unearth and understand Los Angeles requires that you not be passive but be a participant. "I'm just lighting a fire under them, inspiring them to get out in it," Garrett says. "Just sitting at your keyboard giving the stink-eye honestly is not helping the cause." But in common with her online community, she is well aware that L.A. has its rough edges, its doggedly singular take on what it is to be a city.

In the time that Garrett has played host to a cacophony of voices, the city has continued to evolve, the notion of what it is to be an Angeleno alters along with it: And with it, so changes our touchstones: Last century's "Sundown Towns" our parents warned us away from, now reimagined as multi-ethnic hubs. That namesake "river"? The butt of mid-century late-night TV jokes: now a sturdy body of water—reclaiming itself, a destination for fishing or kayaking and picnicking alongside. The generation who yearned for the "freedom" of a driver's license, yet grew up dependent on the car and the web of freeways connecting the region, are ceding space to a new generation of Angelenos who are negotiating the grid by Metro and bike and bus. In their navigation, I hear my forebears' descriptions—of Red and Yellow cars that carried them to the ocean to parties, I hear them speak of green open space to throw down a blanket for an impromptu picnic where a featureless business park now stands. In a way, all of this is a throwback to earlier times, earlier language and associations about place. All of these L.A.s are nesting within one another; they are at the tip of our tongues and at the edge of our memories.

"L.A. is messy. It's like a hot mess of a T.J. Maxx. Not organized. Not neat. But if you lift something up, you'll find some wonderful, unexpected treasure. L.A. is like that when you turn the corner. You'll be surprised. But no one is going to point that out to you—you have to go out and find it."

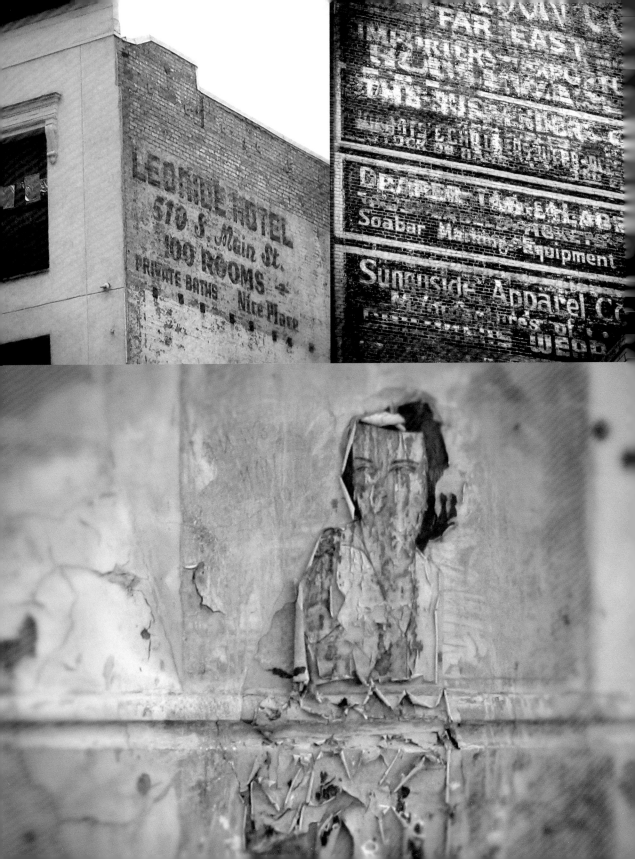

6 *Visions and Revisions*

LOS ANGELES IS FULL OF PHANTOMS. I don't mean apparitions as in bump-in-the-night specters, but the elusive traces of the many cities beneath the city—barely discernible, vanishing rapidly.

I'm not sure when or why I felt I needed to, but somewhere in the last few years I began what I can only describe as chasing ghosts. First it was the faint, stylized lettering sketched along the side of last century's brick and stucco buildings making up downtown Los Angeles's historic core. Yet, before I knew it, I found myself returning again and again to the long stretches of gray boulevards, just beyond it, lined with low high-rises. (We grew up being lectured that heights here were once restricted due to earthquake anxieties; truth told: they were due to "aesthetics" that no downtown building, with just a few exceptions, should be taller than City Hall.) Standing among them, I'd eavesdrop: so many edifices etched with snippets of past stories— the tailors and jewelers, the busy emporiums that once carried "notions;" penny diversions and entertainments; and of course, what so many came west to begin with, the advertisements for space for let: "Private Rooms. Nice Place." Elaborate antique family trees bloomed along stone walls, faded but still apparent. Businesses built on the shoulders of fathers and sons and brothers—cabinet makers and apothecaries—legacies embroidered in the memory of brick façades, if you can pause long enough to see them.

Soon enough I slid off onto a related tangent: A stumbled-upon grab-bag of odd remnants—old wallpaper swatches, the busted tile of a former entry-way vestibule, yellowed mailbox labels with surnames of residents who had long ago fled these parts, long-forgotten alphanumeric telephone exchanges scratched into the edges of old signage in last-man-standing wooden phone booths.

Near dawn, once a week, I'd roll out of bed and set out looking for nothing in particular and come back with shards of something—a curio or puzzle piece of what Los Angeles used to be. I was chasing something: not my own past, but something elusive and larger, but I couldn't yet name it. I began gathering what pulled me, documenting it not in words, but in photographs.

The captures gave me something more appreciable than the language I was still working towards—as I was looking for evidence.

You'll often hear longtime Angelenos doling out directions by referencing landmarks that once stood in a particular place. It's a strange way to live in the present. I wanted to begin in some way to create an album—something tangible that I could hold onto, even if it was missing chapters or felt vague. Our memories are cluttered with such locations. Some addresses have hosted multiple identities and incarnations within one building—like a brick-and-mortar nesting doll—other sites continue to be razed entirely and built up over and over again so often that Angelenos really have to force the recollection, because even the markers nearby have been "updated," "renovated," "retrofitted." What this does to our sense of place, our sense of being part of a whole, we don't find out until much later.

For much of my youth, major city development happened "due west"—closer to the Pacific and its bays and marinas. Downtown, South Los Angeles, East Los Angeles were mini archives, places where early drafts of Los Angeles had begun—often enthusiastically—and put down when some new

distraction, a new territory to tame, presented itself. My old neighborhood in Southwest Los Angeles was spared: Another in Culver City had been off-path up until recently, but now there are long passages I can't recognize at all. So now, with the former—my old Southwest L.A. side streets and main thoroughfares—I have to wonder how much longer it will be until I have to rely on memory to serve.

When you grow up in a place that self-proclaims it is the "City of the Future," you're not encouraged to linger in the past. The present is a work-in-progress, or, more precisely, a launching pad. Consequently, I've become used to feeling a sense of dislocation—disorientation. I've had to, since Los Angeles has been recycled and remade. But what I was now realizing was this: just because I'd grown accustomed to it didn't mean it was the way I hoped to live.

So it began: my ritual of early-morning long walks on Sundays in an emptied-out Los Angeles. Better at that early hour so that I could truly see it—the old bones, the dreams—and find my place within them. These walks have been a way of slowing time down to better understand the city's layered story.

Moving deliberately through these older neighborhoods, particularly on foot, can be a séance of sorts. I navigated with my journalist sense of determination. Driving into some time-capsule neighborhoods—Boyle Heights, Westlake, Arlington Heights—I'd find what appeared to be particularly narratively dense (read: not-yet gentrified but transforming) street and poise myself to listen. I'd walk. And walk. Through familiar neighborhoods where I was now a stranger. Through scents and sounds that were unfamiliar. Sometimes someone would stop to share an anecdote, an observation. Mostly, I let the intersections and blocks speak for themselves. I told myself, just like the process of reporting, it was all about the right source and being a patient and careful listener—that was always how you'd get the better, deeper story: it will, in time, reveal itself.

There were a myriad of stories, with some chapters more brief or troubled than others. Spray-painted tags from warring gang cliques laced dumpsters, makeshift altars with *virgen* votives and drugstore chrysanthemums hugged the base of street lamps. Sidewalk chalk markings acknowledged yet another one fallen, another "in memory of." Sometimes I could read the tension on the walls, as one 'minority' majority cedes to the next and then the next. People live on top of histories they know nothing about, but more and more, I'd come to realize they didn't want to know. Murals of past community's leaders painted over to extol and celebrate one's own. One's hope. At a certain point does it matter if the leave-taking was because of fortune, failure, fatigue, or race-fear flight? It's like raising a flag, claiming territory, the turn of a page: "Our story starts here. Now."

These walls, walkways, and vestibules slide open a memory door. It may not always be a personal one, but they might unlock some story, a long-gone relative once told me. Or maybe they unwrap an old anecdote that one of my interview subjects might have once shared, with an elaborate wave of the hand: *You're too young to remember there was a baseball field here. There was once a whole neighborhood right through here before they built the 10.* They pull a curtain back on a Los Angeles of trolleys, of orange groves, of gentility—even in the Wild West. A Los Angeles that had space to work in, room to imagine and to encounter yourself.

I see evidence of those dreams and the space to have them in the distinctive flourishes of these signs. Not just the painted walls or the crumbling shingles, striking in their decay, but also in what else has survived and still peeks through: the cursive of old railroad tracks that trace a block or so and then disappear below asphalt, the concrete staircases leading nowhere. How did they get bypassed? How did they get spared the wave of forward thinking, progress pushing itself west and north across the city?

This ritual of mine, I came to realize, isn't an act of nostalgia. There is, however, something essential in connecting past-to-present dots in a place that so often erases antecedents. We lose not just brick and mortar edifices but traditions, and with them the ease with which one moved around and explored places—and our sense of what it was to be an Angeleno.

What goes missing with all of this remaking is a true sense of progression, context. Without those there-to-here stories we are always starting from scratch, out of nothing, so it seems. And though that has long appeared the very point of Los Angeles—a city of clean slates, of new beginnings—the city loses something: a sense of its own narrative.

Spirit and sense of place, that *genius loci*—what a destination is imbued with, what it conveys—is what we forfeit with this constant remaking. That *feeling* has faded. These old signs are the visual equivalent of a waft of old perfume—a powerful mnemonic hurtling us back in time.

Now, when I think back to when I started all of this, it's no surprise that I was truly struggling with Los Angeles. I still loved the idea of it—the ghost of it—but didn't particularly like *it* any more. The place I traversed daily felt loud, brassy, and empty. The things that mattered to me had vanished—family, addresses, legacy—and with them touchstones and the meaning behind them. What do you share if "it" is no longer there? Perhaps these trips would reignite something, or perhaps they would allow me to make peace with what it had become and begin to say goodbye.

These Sunday collecting trips were telling me that with all this incessant reimagining and rebuilding we were essentially erasing one sentence after another because we felt it didn't read right, or it wasn't quite what we wanted to say. But maybe, more accurately, we were thinking too much about how we wanted others to see us, rather than probing deeper inside ourselves. What pieces of our journey were imperative? We had rewritten our story so frequently that it had lost its weight and clarity, its essential meaning.

Some years back, I lived on an odd slip of a street in Echo Park where a Victorian mansion capped the end of the block. Not only had it fallen into tragic disrepair, the storybook house no longer had any relationship to the rest of the structures lining the street: a hodgepodge of bungalow courts, dingbat apartment buildings, and down-at-heel Spanish-style cottages. But that was the house's charm, the street's charm. After I'd lived there a few years, the house was spirited away—uprooted from its foundation in the middle of the night. In the light of day, I noted that only a piece of cement staircase that once led from the sidewalk up to a dramatic wraparound porch remained. In time, a small homeless encampment grew up around the steps and the remnants of the decrepit porch, lending the squat a semblance of a grand entrance. Those stairs remained for nearly a decade—a conversation piece, the beginning of a poem, a monument to steadfastness—until bulldozers and other big machines arrived one morning, early as roosters, and got to work, knocking and pushing the last little bits of past around the loosened dirt until there was nothing. Days later it seemed a maze of a frame went up on top of a new concrete foundation. Then in mere weeks a featureless condo rose from what had been. That history gone, erased. No trace. Now, I realize in hindsight, that moment wasn't an isolated event, but part of the neighborhood's very first major wave of gentrification—one that continues still.

I grieved that building as if it were a person, or at least with a spirit of one. Essentially, for me, it was. That out-of time structure was a reminder of another Los Angeles and a different way we lived, interacted with, and thought about place. It had a story. Now only the architecture of its memory, within my own memory, remained.

I wonder what gentrification's stories will tell residents of the future about *us*? What ghosts they will be able to summon, what legacies our signs will tell about us sixty, seventy, 150 years hence: the cacti shops, the pet

accessories boutiques, the wink-and-nod haberdashers—the places and proprietors who trade in a nostalgia that isn't even their own? Will there be any real brick-and-mortar clues left, or will it only be these images in my hands that all too often, even now, without necessary context or history, read a bit like non sequiturs?

When I was much younger it was exciting, comforting really, to feel as if you always had the fresh start Los Angeles implicitly promised, right there, at the ready, the trick up your sleeve. Now, decades gone, I realize that if you're not careful you might always be starting over. You might never sustain, let alone finish, a thought. What then is your legacy? What endures?

If we're mindful we can etch out our from-the-heart intentions along our daily pathways, and if we're lucky they too will be hidden chapters to be stumbled upon over time. Stories that can whisper across decades, centuries—even on this island of impermanence. But that would require that we know who we are and what we stand for: not empty ambition, not someone else's nostalgia.

Like the faint cursive threading across all that old brick, to really be part of a city's story, to truly be tied up with the spirit of a place, requires leaving some tangible, meaningful piece of ourselves. Not something one pays millions in naming rights for, not a monument to money floating over a transom, but an offering: the everyday sweat and hope and longing etched into the nook of an old phone booth ("Call me"), the heart-framed initials scratched in the window seat, even the "& Sons" traced along the faded wall. It's not just that "I was here"—but it's why.

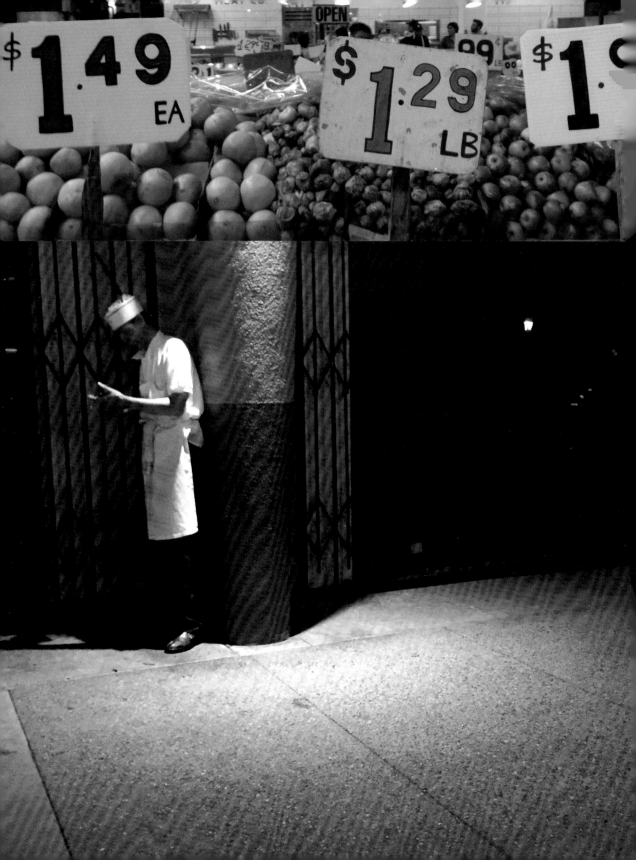

7 *Between Here and There: Dispatches from the Third Place*

It's time for me to quietly watch the world and even enjoy it . . . then just calmly walk and talk among people of the world . . . that's it, be a loner, travel, talk to waiters only. —Jack Kerouac, from *Big Sur*

IT'S LATE, AND I'M UP, scrolling in the dark.

Not long ago, that "c" would have been have been replaced by a "t," and—even deep into a Sunday night, after a long wander—I would have been ringed around the glow of some restaurant four-top with friends from distant posts across the Los Angeles basin.

Tonight, as it's happening more frequently, I'm making rounds virtually.

Among the filtered instant captures crowding my feed on one social media app—a succession of beach sunsets, craft cocktails festooned with herb sprigs, the overstuffed-to-tilting burgers on glossy brioche buns—something stops my scrolling thumb.

Out of one image's fuzzy-dark murk rises a simple detail: a painted gold variegated star nestled within a blood-red heart. The vantage is so close, the context is stripped away, but that floating heart and star look not just naggingly familiar, but familial.

The image gives me misgivings; its caption answers my fear. " . . . Are these not the places that make our city full of heart and memory and sensory

experience?" the poster asks: "More than trend, more than food as a vessel or development or monetary hot investment. You guys, these are the places that we're losing "

That star, that heart, the over-spill of words crowded below: It was a eulogy for a destination that had long been a part of me—"Farewell, Cha Cha Cha," she signs off.

This news registers sharp and loud inside me. For years I'd joked to friends that Cha Cha Cha was my kitchen table, but really, it was an essential coordinate within my L.A. cosmos.

When Cha Cha Cha Cafe first opened in the late 1980s, brainchild of business partners Mario Tamayo and chef Toribio Prado, the location was considered to be "far flung"—at the very edges of imagination. That lent to its mystery, its cachet. Crowning the corner of Melrose and Virgil Avenues in East Hollywood, it stood out along a strip dotted with metal shops, a car wash, Laundromats, and tire stores. The tiny, once-plain-Jane storefront flirted with passersby. The owners frequently boosted its street presence with fanciful paint jobs—powder blue, goldenrod, Schiaparelli pink—enhanced further by other whimsical facelifts—corrugated metal siding bent into Seussian zig-zags, palm fronds sprouting every which way, like exotic headdress plumage.

Cha Cha Cha was always a party in progress: Flowing cumbias sailed over the speakers; pitchers of sangria and platters of inky-peppery jerk chicken and pork—balanced on the able palms of waiters—drifted above our heads. The interior, a mix of floral-print, oilcloth table coverings and mismatched chairs, was surrounded by hand-fashioned assemblage pieces—elaborate altars, shadowboxes—tucked into discrete nooks. The roof leaked even in the gentlest rain, and for all of those seemingly bottomless sangrias, the only downfall was there was only one stall apiece for men and women. But you made do, because it was Cha Cha Cha.

Positioned equidistant between my home and work, Cha Cha Cha wasn't

simply a pitstop, although it may have begun that way. Initially, my head had been turned by its busy tropical menu, which embraced the cuisine of South and Central America, Cuba, and Jamaica. But I fell hardest for its freewheeling and unpretentious ambience. On any given night, its cramped space was a feast of post-work talk. You could eavesdrop on in-the-trenches organizers or off-duty LAPD officers. City Hall and L.A. County Metropolitan Transit Authority employees sat shoulder to shoulder with nightly news talent from the television stations nearby. Not that I could report on any of it, even still, as a young reporter, I knew I'd hit gold: The inner workings of L.A. spread before me *and* I would be well fed. Seven days a week, from "8:00 a.m.-Until. . ." Business, both formal and extracurricular, happened here. Most significantly, the restaurant was a crossroads, one of the few distinctly multiethnic meeting spots, where L.A.'s diversity was on vivid display. I knew, not simply as a participant/observer, but as an African American journalist writing about race and place, that this too was manna: It was L.A. as its best self.

To think I'd never walk through that gate with the heart, or dodge the run off from a sudden cloudburst, was painful to fathom. So much history there, so much learning and becoming in the space of long conversations tossed across a wobbly second-hand table.

Already, 2016 had been rife with monumental loss. Essential pillars of my youth were falling like tired trees—writers, singers, activists who'd helped me to forge a sense of myself. It was wrenching enough to lose a mentor—the voice, the guiding hand—but losing a place, a hangout, that essential "third-place" that played host to your own self-making? That packed a surprisingly similar, disorienting body blow.

As cities, go, Los Angeles, it seems, sheds its built history faster than most. As a native who has negotiated this reality for decades, I thought I'd become inured, made peace with this brutal fact. I'd witnessed so many landmarks go—grand hotels, department stores, writers' residences. But there are these special spots that connect us, that span generations, and therefore

become repositories of vivid collective histories.

As you move through the city over time, you come to understand that the notion of vastness here is double-edged. I like the sense of possibility implied with a late-night drive through emptied streets that might pull you into a corner of the region you knew nothing about. Discovery was enabled by chance, an open-endedness, a flow you could fall into.

Vastness also meant you may never get back to that gem you uncovered. It also may mean you'll fail to find the time to revisit an old neighborhood you'd explored so thoroughly that you'd memorized it. Place—a working sense of it—was made up of not just the streets, but also the people you encountered—their stories, their memories, their battles. Sometimes, when someone references an intersection, not the streets, but a face drifts back: I wonder what happened to the men and women who passed my *café con leche* and *pastelitos de guayaba* across a worn counter most mornings for a decade at Cafe Tropical? Did Sparky the artist who sketched a population of beach cronies and cafe philosophers on nubby two-ply cafe napkins at the old Rose Cafe in Venice ever get a big break?

As traffic and density rewrite our understanding of city, too often we're pulled to places of convenience rather than seeking out those that speak to some soul-deep pull.

I miss the strolling. The wandering.

Even still, we find our physical comfort zones, make our rituals. Each of us gravitates toward something specific. Some look simply for expediency. Others for conviviality. For me the best third place—that "let's meet in the middle" destination—provides a sense of community. In a city that is often derided for having no center, what third places and the folks who work in and frequent them provide, is context and connective tissue. With them you don't feel as anonymous. They reframe and shape our connection to the larger city, filling in the missing parts of a story you can't access first-glimpse. This requires a loyalty on your part. It coaxes a little more out of you than a

tip on the counter. It requires engagement.

Mondays were my Cha Cha Cha roosts. My table, tucked into a far corner in the palm-frond-adorned patio, gave me a clear view of all comings and goings. I was enough of a regular that in the years before cell phones or online "check-ins" friends would call the restaurant if they were looking for me, knowing that there was a best-odds chance I'd be there.

While I'd often meet up with colleagues post-work to commiserate or celebrate, there was always a moment when the servers would slide by to catch us up on their own lives—school-work, side-businesses, neighborhood struggles. I watched one server bring his young son in over time. He grew up before our eyes. First shadowing him as a busboy. Then waiting tables himself. He would marry. Start a family. Buy a house. His father proudly reported each new step along the way.

You felt tended to on every level: Even the valet who orchestrated the cars in a way that felt as insolvable as a Rubik's Cube—he always remembered, without the ticket, whose car was whose. On chilly nights, he'd sometimes just be in a thin, short-sleeved shirt. "Tequila is my sweater," he'd joke—you hoped—as you handed over your keys. But I'll never forget his largesse. One evening, while I dined, he'd detected a flat on my left front tire—and then changed it. Presented it, a done deal. No, not just a kitchen table, but home.

These third-place voices—the waiters, chefs, busboys, bartenders, who always had a good word, an insight or a cautionary tale—were as important to me in parsing this city as the scholars who dissected it, or the novelists who tried to fix it on the page. These men and women with whom I sat on stools and near the loading dock beyond the kitchen, taught me about *their* Los Angeles. I learned about the many layers of the city, and through them I began to envision it as a region as deep as it was wide. I learned about sponsorship and immigration and steps to acquiring languages—from ESL to "kitchen Spanish" I heard stories about the intricacies of moving through the maze of naturalization. I helped busboys write letters to landlords or

their child's teacher. I learned about front- and back-of-house tensions and discrimination—the hierarchies of accents and which ones were more "desirable" for front-of-house jobs. I learned about life between here and there; being seen and unseen. I listened first as a customer, then a journalist and later as a friend.

There is this notion about waiters and Los Angeles (and cities that trade in dreams—New York, Washington, D.C., in particular)—that these jobs are simply momentary, on-my-way-to-another-life gigs. Over the years here, more times than I can count, I've listened attentively to script-optioning strategies or tried to calm an actor's call-back jitters, before I've placed my order. It comes with the territory. But the folks who I became closest to were fixtures in their restaurants. They would tell me that they loved the flexibility, camaraderie, but I saw—no, *experienced*—something more. Something I and everyone else they encountered deeply connected with over time. It was in their blood. They gave meaning to the word "hospitality."

Over the years, I cycled through hangouts. Miceli's in Hollywood was pure time-travel—family-owned since its opening in 1949. A red-sauce and checked tablecloth pizzeria that was—and still is—all mood. On and off, through the late '80s and into the '90s, Miceli's became another perch for me. Just minutes away from my old office in Silver Lake, it was in the thick of a transforming place.

Back then, the streets surrounding the entrance to Miceli's were a jumble of cross-conversations—faded-glamour Hollywood, ghost Hollywood, grungy Hollywood. Given the night, you might find a single platform shoe alongside a pile of broken windshield glass and a runaway reciting his hard-luck story. Stepping across the threshold was time travel. Inside, depending on the night, there was live, solid, straight-ahead jazz; the last big gust from the old studio musician days, in the upstairs bar. (My favorite jazz DJ at the time, Chuck

Niles, was known to slide in after his on-air time some nights.) And when the owner, the gregarious Carmen Miceli, wasn't there to greet you, Eddie did the honors. Salt-and-pepper crowned, Eddie was a man of few words. He spoke with his eyes—which widened or darkened, and sometimes, he italicized with an arch of the brow. He ushered you to a booth in the corner *if* he liked you enough. He'd boot you without much warning if he didn't.

This spot was an anachronism, pure and simple. But as a place to rest your worries for a moment, it couldn't be duplicated. It set enough of a mood to attract all manner of population. I lived for it on weekends. These were the post-punk years, so the clash of the jazz and the metal-leather crowd told an unfolding story about Hollywood.

There were those places you dipped into with visiting friends or family. Like Les Frères Taix in Echo Park that always felt like dining in a gilt-edged oil painting. With its career waiters who pour on rich *biens* and *s'il vous plaits* for newcomers. (Taix had served as my family's decades-old haunt, stretching back long before I was born, to the time when it was downtown on Commercial Street.) Like Musso & Frank Grill or Philippe the Original, their role enshrining city history, the stories recalled, passed on, often eclipsed all else.

But, there were places that became true hearths—the pull? The people—both front- and back-of-house staffs. The bright-eyed hostess at a Valley bistro "just over the hill," I'd come to frequent, years later became a real estate agent. On eleventh-hour notice, she found and secured my new digs—a sweet storybook cottage—after my old living situation went from fairytale to horror story. There, too, I'd met a chef who hailed from the former Yugoslavia. Reworking the menu upon his arrival, he'd almost immediately, it seemed, eighty-sixed my favorite dish—an aromatic, pan-roasted chicken. Solid, post-hard-day-at-work comfort food. For weeks afterward, we were engaged in a full-on, freeze-out war.

Until.

One weeknight, I was settling in with friends, scanning the new offerings. Suddenly, out of the kitchen, the chef himself strode to the table. With grand flourish, he placed before me, a precisely executed, miniature version of the dish, composed instead with a Cornish game hen resting next to a tiny mound of *pomme frites*: "You weren't the only one upset. I'm bringing it back. Promise. Truce?"

Relations thawed. Over talks and time, through him and his stories, I peered through a window onto Los Angeles that would have been impossible to otherwise know or to be privy to. His kitchen—and others he'd worked in, were populated by a network of émigrés—from El Salvador, England, Mexico, France—who weren't simply disconnected from their respective homelands but living in a strange emotional territory that was neither homesickness nor nostalgia. Through me, he hoped to get to some necessary footing; always asking thorny questions about race and the strange dividing lines in Los Angeles he had yet to translate or unravel. One night, we ended up in a converted cantina deep in the Valley, a dark hangar of a room overwhelmed with gray-blue cigarette smoke, little-to-no English spoken: "It's Serbian New Year." He announced, while jockeying for stools for us at the busy bar. Rising to find a bathroom, he stage-whispered conspiratorially over his shoulder: "If anyone comes and asks how you are say, '*Dobro.*' If they ask where you're from," he said with a squint, knowing he was once again pushing things, crossing the line, "tell them, 'Montenegro.'"

Mastering place here wasn't simply knowing how to move through the interchanges or canyon passes. Those were important rites of passage moments for me, yes. But, more crucially, what makes a city yours is the act of claiming and naming signature far-flung Los Angeles—a galaxy of pit stops, alternate routes, and hideaways that speak to the depth of your

curiosity and engagement.

One restaurateur I came to know extended the bridge even further. West Hollywood's Itana Bahia was known especially for its authentic, difficult to replicate seafood dishes—prepared by the woman who was host, owner, and chef. I met Itana, when she began throwing a series of World Cup parties after Brazil made it to the semi-finals in 1998. As the team advanced, she trimmed back her list, reserving space only for the small core group who had assembled from the beginning. She wanted to keep it intimate, "For family." In advance of the finals, she prepared dish after dish of off-the-menu delicacies, a special good luck menu. For all her travails, Brazil lost 0-3 to France. Despair flooded the room, but only for a moment. Itana lifted her head, cranked up the stereo and urged all of us to rise. We tumbled out the door, the music snaking behind us. An impromptu samba line begun to stretch along Santa Monica Boulevard, stopping traffic. Confused motorists called out to us: "Wait! Did they *win*?"

For months afterward, I continued to pull in friends and family to dine on *moqueca de peixe, bacalhau,* and *pão de queijo* and listen to deep-cut mixes of musicians Elis Regina or Chico Buarque. Those CDs were gifted to her by other Brazilian expats who'd stop by to scan the evening's specials, or simply to swap news about the old neighborhood. I began to gather other pieces of Itana's story. She'd come here to help her family at home get a leg up, to pursue her own dreams and education. But she missed her mother and siblings terribly; the way Bahia had settled within her and shaped her imagination. Itana's was one of the places where I began to truly understand the deeper meaning of the Portuguese word *saudade,* a term I'd hear in the lyrics of so many sambas and bossa novas I'd grown up listening to. *Saudade* is a longing for a departed person or place that brought joy. It's coupled with a painful awareness that the object of that longing may never return. Deeper than melancholy, it's a memory of a desire. Staunching that heartache some, Itana's mother visited from Bahia to help out in the kitchen. Ultimately, what

they cooked up was a plan to take me home with them: Three weeks in Bahia, where I roomed with her family, learned to make *feijoada* and properly chiffonade and season Bahia-style collard greens, and tried my best to sync up with Brazilian time.

I'd always taken pride in the fact that I'd grown up in a world city that allowed for these connections. I knew what we had: the mix, a flow, a broadened way of looking at the world. Food was the draw; it was the enticement that got.you to the table. Then you lingered for the conversation. Essence made tangible.

L os Angeles can feel much smaller, gentler when you have a series of personal pins on a map, a place to enter through, one that becomes part of your story as you learn its story: It's at the core of place-making.

Just last summer, over the same platform that I'd first learned of Cha Cha Cha's shuttering, I received what felt like impossible news, that chef Toribio had, quite suddenly, died. "I don't know how to start this," his nephew began in a private message, "He was my second father, a loved one to many he came across." Yes, family.

The news shook my center, was impossible to process. It underscored how fragile these strung-together moments that together make memory are.

I'm certain that I won't ever be able to replace the sort of third place Cha Cha Cha was for me—my always available "kitchen table" where I could arrive famished after a long swim at the Echo Park pool and just happen into friends; or where I might take a pile of work and linger over a simple plate of off-the-menu scrambled eggs, or wander in on a Sunday morning with my mother for a fancy, impromptu "just-us" brunch. These things evolve into what they may be—you can't force them into being.

If I'm honest, I can't say that I couldn't see it coming, yet another "far flung" neighborhood "discovered" and reclaimed. Even so I held out hope that it would somehow elude the press of progress, that it would hang on like some stalwarts—the Apple Pan or the Pantry—forcing progress to find its place around it. I watch these new watering holes rise up—cookie-cutter minimalist. That sameness fills my social media feed: An Instagramable echo. It's why that star and heart stood out; it was *sui generis*, like Cha Cha Cha, and of its moment, now passed.

You find your third-places where you do—barber shops, newsstands, dog parks, a bench on a bluff—the places where, yes, people know your name, but even more acknowledge the value of your presence and feel the weight of your absence.

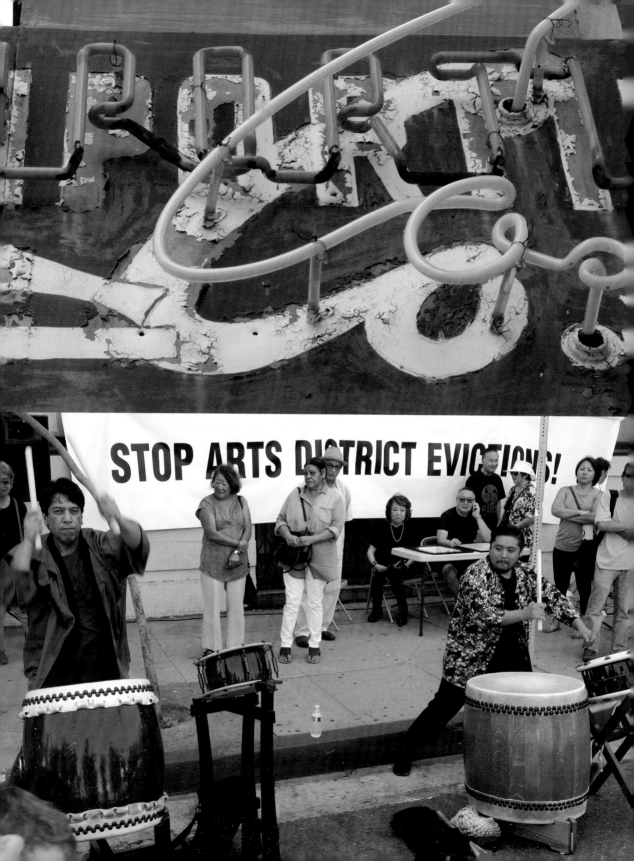

8 *Here comes the neighborhood.*

*We have become accustomed to figures disappearing from our land-
scape. Does this not lead us to interrogate the landscape?*
 —Richard Rodriguez, from "Late Victorians"

RAZING GHOSTS

I resent the hectoring GPS that overcorrects my turns, that edits my cir-
cumvention. I silence it with a "I-know-better" finality. Because generally,
I do, but truth be told, I'm stumped: I'm idling in front of a row of blank-eyed
storefronts emptied of I am not sure what.

The address I've scrawled on scrap paper doesn't square.

Again, disoriented at home.

I eye a newish, low-slung, coolly lit restaurant where an old high school
friend and I had dined and reminisced recently. Though we both had trav-
eled up and down this boulevard weekly, we couldn't recall its former incar-
nation. "Shoe store or. . .?" This troubles me, mostly because, I *should*. I've
taken it as my task to remember the progression and story of neighborhoods
I pass through regularly.

I stash my car, and now, on foot, arms crossed, I stare back at the glass
storefronts full of used-to-be and soon-to-be and try to solve the riddle of

the address.

I could be anywhere.

This occurs frequently of late; faster and faster it seems, as I move about Los Angeles. Something's vanished. An address or location not traceable or easily discernible. Even more vexing, however, are the gentle re-imaginings that at first glimpse or along the periphery, all seems well, but, taken together, upon closer inspection reveals disorienting change.

Following the soaring peal of a familiar laugh—a touchstone—I slip down a hallway that finally points me toward the party's destination. The spot is a sly, speakeasy sort of room that was once an old furniture store. I am learning this background and context from a woman who is chatting up my friend, whose laughter led my way.

I'm late and so are others, referencing the same reason, lost amid the familiar. The woman speaking also found herself circling around a once-known neighborhood but now feeling utterly disoriented. "I'm even feeling that in my own neighborhood."

"I used to. . .," I offer.

As she unloads her weighty misery about her evolving district—shuttered amenities, altered landscape, traffic, rising rents, the new people who don't meet her gaze, I realize she's speaking about my old environs. My "Pop and Pop" pizza spot, as an old boyfriend used to speculate, is not her go-to cornstarch crust hangout. No. Rather, the Echo Park she's waxing nostalgic about is the Echo Park I decamped more than ten years ago because *it* was changing, and I couldn't afford—financially or spiritually—to stay.

She's escaping craft coffee and pricy brunch spots; I was fleeing edging-up rent and peace-shattering nightlife (college boys and their smashed beer bottles littering my landing, a chemical-tinged odor slipping from beneath another neighbor's door.)

We weren't talking about the same place.

Her Echo Park is not my Echo Park.

Her arrival triggered my departure.

We lived in two very different places that just happened to have the same name.

I'm reminded, as she un-scrolls her list of gone but not forgotten, that increasingly of late I have found it difficult to locate common ground. Or, I should clarify; I'm finding that sense of common ground and communal connection across time have become a different sort of calculation. The way in which we remember place, the details that root us in a temporal or tangible locale have shifted such that I can't always volley with a hearty, empathetic "I know what you mean. . .." Because, truly I do not. I've been avoiding looking back. Too painful.

That is the nature of place, of neighborhoods: they shift and change, are remade by not just the residents but by politicians and developers. They always have. I have grown up on shifting ground. Negotiating it. Memorizing it. And I suppose it is why I require stories, evidence of who *was* there and why.

Gentrification—the word, the process, the consequences of tearing down and away—doesn't get at all that is at stake. The very particular uniqueness, flavor, story—these are all of what we lose when environments are snatched away, paved over, remade.

What I know is that absence is much more difficult to articulate. The city doesn't just look different to my eye. Its very pace and spirit has been altered. You encounter it on the road: the anxiety and impatience. You absorb the lack of interaction. You lose people—a diversity of citizenry—and with it, their mores and point-of view. You surrender something—an inflection, a flow, a vibe—the very thing that makes a particular city unique.

I am not alone in these observations. Every week it seems I am listening to some grim anecdote about some hard-hearted landgrab or lost home or dashed dream. There's urgent word of a new tenants' union popping up.

There's a critical protest to attend. Don't forget the petition you must sign. I keep thinking about the young man who agreed to speak to me about his family's displacement and then, I supposed, had second thoughts. He didn't say no outright. He was polite in his reshuffling of days, turning pages of his mental calendar. But he vanished, and took his—and his family's—story with him. I don't fault him for his unease or distrust; he'd already lost so much; he could protect his story. I didn't want to push, because I didn't want to pick at what was not yet a scar, but still a fresh wound.

"WE HAVE NO PLACE TO GO"

I hear the rally, its low-key ruckus, before I actually see it. The taiko drums send up a call. The roll and flow of the rhythms pull me forward. The flier suggested that protesters should gather at 2 p.m. Supporters took them at their word. I eye my watch and see they kicked off right on time. I quicken my step and feel my camera bump against my hip, but I don't feel the need to raise it—not just yet. I'm not even tempted to pause. I take in the changes in motion: the shoppers and strollers, the boutiques, the pubs, and a fancy ice cream shop. Just off Hewitt Street, I glimpse a flock of fragrant food trucks fanned out, parked nose-to-nose-to-nose and white tents beneath which vendors hawk expensive soaps and halter tops—in other words this could be anywhere in Los Angeles—or anywhere else for that matter.

I make my way, winding through the drifting crowds of tattooed girls in flour-sack dresses and platform corkies alongside the Westside and Valley bros in flip-flops and sunscreen-slashed noses. These new features have turned this place into a just another stop to pop eye candy, buy pressed juices, or shop for knick-knacks—including pricy burlap totes with the neighborhood of your choice—Echo Park, Boyle Heights, Atwater—stenciled on for free. There's good coffee and a Warby Parker outpost—the online optometrist—where you actually can try on glasses before you order them. But sometimes when you

walk in, ironically, the clerks don't always seem to see you.

I wonder what my old acquaintance Inez would make of all of this three-ring, high-end "experience." I slipped out of touch with her more years ago than I feel comfortable even attempting to tally. As time and jobs moved on, so did we. She's not someone I would ever expect to find on social media. I wouldn't want to encounter her that way. Not at all. Her world didn't work as such. *She* was someone whose neighbors gathered around on her busted cement steps, mere blocks from here, as I recall, closer to the concrete river. News flowed to her and through her. As I reassemble these details, it occurs to me that I don't remember if she even had a phone. You had to catch her, happen upon her mid-stroll. She was an artist and one of my introductions to the idea of an informal artists' community, to a different way to see and understand Los Angeles.

This end of downtown—the easterly edges of the Historic Core into Little Tokyo and the Arts District—has been changing for some time. Both slowly and quickly, depending both on your personal measure and to whom you're talking. Quite recently, however, within the last three years or so, it has begun to look less like itself—meaning less particular, less beguiling, more like a tourist hub than something you would wander upon and circle through with wonderment. This was a place that for years I would come to take a visual breaks from L.A., to get my bearings—probably in the same way some slide out to the ocean in the early morning. It was lonesome and wide open and had its own sense of forlorn beauty. One Santa Fe, the hulking multi-use complex that resembles an elongated cruise ship now shuts off both the open-ended view to the train yards, and the reach toward Boyle Heights and into deeper East L.A. Squint and you might still recognize the bones and lines of past industry, the crisscross of rail-ties, still there, but you'll have to know where to look to see them. So much has shot up and closed in, I find myself turned around once more.

The drumming pulls me toward the stencil-and-graffiti-laced sidewalk stretched out before the old Joannes Brothers Building at 800 Traction, a newly contested spot that's been in the news of late. There are about a hundred people gathered on and near the sidewalk facing the Traction side of the structure. A white banner with bold black letters billows in the summer wind: "Stop Arts District Evictions."

In May 2017, DLJ Real Estate Capital Partners acquired the Joannes Brothers Building property—as well as a neighboring structure—reportedly for the combined sum of $20 million (or $305 per square foot). Shortly thereafter, the sixteen tenants inhabiting the live-work spaces were given notice to vacate. The building's future? More than likely another conversion to mixed-use or "luxury condos" the transformation of the moment.

Designed by Los Angeles architect John Parkinson (whose L.A. signatures include City Hall, Bullock's Wilshire, Union Station, and the Coliseum), the Joannes Brothers Building, with its august brick-and-stone façade, has loomed over the neighborhood for more than a century. It has already weathered various incarnations—still bearing the names of its former occupants like lost-love tattoos—Joannes Brothers Company and Angeles Desk Company. It also was once home to Ben-Hur Products, Inc., a California-based producer of coffee, spices, extracts, tea, and desserts, until it became a residence for working artists who had the vision to see not just home, but potential in a segment of L.A. near the river that hadn't been on anyone's map.

By July, just half the occupants remained. The new owners had offered no relocation compensation, and the tenants had no easy recourse. Like my friend Inez, they'd landed their spots here when the property was a live/work setup that meant that the landlord/renter agreements were handled differently than in a wholly residential building. So they would fight.

Many of them, now in their sixties and seventies, had moved to this

neighborhood when it was still considered to be part of Little Tokyo—and therefore in certain respects, part of the grievous history of Japanese American internment. "We've been fighting eviction for seventy-five years, " one of the tenants now stationed behind a microphone, intones. "That the majority of the artists who will face eviction are Japanese American isn't an incidental detail."

The transition is a loop: A continuation of long history of upheaval and erasure of people and that takes many forms: eminent domain, redevelopment, urban renewal, and gentrification. "These are assets," he underscores, "that we can't afford to lose."

Another tenant slides in to speak: "When we moved in, none of this was here," with the sweep of his arm he gestures toward the strip of busy cafes, boutiques, and condos, I'd passed along the way. "It was our dream that it would all happen. But we didn't realize *we'd* be evicted when it happened."

The audience sends up a wave of supportive applause. The bros shuffling out of the fancy beer and sausage spot across the way on Third Street pause to listen to threads of the talk, and with furrowed brows move on. A pair of LAPD officers stands by, attempting to keep the crowd from interfering with the flow of traffic, as the party and the protest blend into each other.

A young man with sandy brown hair standing at the lip of the sidewalk, slightly apart from the proceedings, leans in, filling me in on some gaps—the sentences and contexts, I can't quite make out for the ambient noise. At first I take him to be one of the curious bros from the hot dog spot or the bakery just up the way, but no, he too lives at 800 Traction, and this might be one of many displacements he could be facing in the space of only a few years— hopping from Highland Park, the Valley, Koreatown, and now this? What's next? His shrug answers: "Who knows?"

What's different from the experiences he's witnessed previously is that this neighborhood has leapfrogged over the expected "tipping point"—those signs one sees that often indicate a steady and sure path toward gentrification.

"We bypassed the Trader Joe's and the Whole Foods," he reports. "Oh, we're getting a *Dean & DeLuca*!" His articulated italics meant to be sardonic.

He turns his gaze toward a four-story building situated diagonally from where we're chatting. While largely nondescript, painted an industrial off-white, the low-rise has long been a marker of mine in the years I've been visiting the neighborhood. Most recently, I would find myself looking up into the windows facing Third Street to see what might be floating from an interior ceiling or propped up, on display, peeking out from the window. Vintage blown-up yearbook pictures now quickly come to mind. All that's gone. I see that now. Tenants and effects and stories, gone. "It's eerie. . . see how some of the windows are still open? Some completely. Some just a little. It's as if they just stepped out. As if they will be coming back soon."

I'm lingering at the edges of the crowd, waiting to hear the artist Nancy Uyemura speak. Two mutual friends suggested we try to connect, as she's been in the building since the early '80s, throughout the years I've been rolling through. She also had a long history in Los Angeles, and too, like me, she is a native. She leans forward into the microphone and begins to speak about her time downtown and all the remade landscape, but I find myself struck and snared by these simple words: "You wouldn't have an arts district without artists. But now I have to ask, where are the artists? How many of us are even left? And *now* where do we go?"

As the event winds down, and the drummers start up again, I finish confirming appointments for interviews. I count the business cards I've collected and am unsettled by the number of people who have stories about displacement, evictions; the people who are worried about not having anywhere to go. As I turn to make my way back to the Metro, Nancy's words continue to circle. "Where are the artists? Where do we go?"

I realize part of the heaviness I feel is rooted in a sense of dislocation and distraction. I keep looking for Inez's old place: brick-faced, cement stairs, steel-pipe railing. I am trying to picture, no, conjure Inez—a flash of her in

oversized t-shirts, sateen paint-ruined PJ bottoms from the old thrift stores she haunted. Living in a building zoned for nothing more than making art, she made her home around her sheaves of papers and canvases, brushes and pots, and tools—her works-in-progress; her life, too, a messy work in progress.

Just how did I get to her place anyway? It's difficult to retrace my steps, my turns and shortcuts of so many years ago. It's all gone, it seems. I wanted to happen into her, like the old days, crouched on her doorstep, stacking the pink pastry boxes filled with homemade pies she'd bake to earn "make-ends-meet money;" her broken boombox picking up only AM lounge or big band music. You just as easily might find her reading the day-old newspaper or dipping into one of the stripped-cover mass-market paperbacks she'd fished out of a dumpster—Signet Classics and murder mysteries—spoils of the across-town bookstore she worked kitty-corner from; the bookstore, I worked in. How we met. The memory of place. Of what it was. And what she might become because of it.

How I remember it may not be exactly as it was, but that doesn't really matter. It was the example I took away from it. That front stoop was an entryway into a different sort of life. A map. A key. This woman of color, a work-in-progress, who called herself an artist was a model for me. All of this—past and present—is tied up in that place: the intersections, the telephone lines, the busted concrete, the pink boxes, the broken boombox: a life outside of the expected structure.

We arm-wrestle over land, every square inch. In those blank storefronts, I step briskly by, chasing the sound of my train, I see a mirror of what was, where developers and new dreamers see only what will be.

COLOR WITHIN THE [RED] LINES

I have been yearning for a time machine for as long as I can remember. Not for the purposes of nostalgia. It's not my memories I want to revel or

bask in. I've always wanted to crawl back, deeper into Los Angeles's past to *feel* and see what it might have been. Its scents and textures that announced seasons. Who populated it? What did it sound like to stand on a corner and listen to a streetcar charge by? What did it sound like to walk by clubs or people's homes with their doors or windows flung open? What news filled the pages of the papers open on their kitchen tables? What was on their minds?

Ever since I began reading old novels about Los Angeles, I hoped that I might find a little sliver of it left somewhere, left entirely intact; some forgotten neighborhood. Sunday afternoon rides through the center of the city with my family fed this fantasy. Often I'm presented with holes or dead-ends. I arrived, it appeared, just a moment too late.

Now, long-past grown, I still look for traces everywhere.

Back in the '70s and '80s, I was captivated by the urban legend circling around the old Original Spanish Kitchen on Beverly Boulevard. It had been closed since the '60s—my entire life almost, but if you pressed your face against the windows, you could see set tables with checkered cloths, a pot on the stove, and shelves with appliances and provisions—all ready for tomorrow, whenever it might arrive.

Time erases many of the particular and peculiar stories I'd heard: A murder; the owner just mysteriously walking away and into the ether. What I later understood was that there was something galvanizing about the mystery, the open question of "what if?" Here was a neighborhood story that changed hands, and continued to be embellished, from decade to decade, like a quilt. The property remained in limbo well into the new millennium, only to become an L.A. cliché—a beauty salon.

That arched window with the half-moon aspect wasn't just a time capsule, but prompt, as it inspired stories from locals, a path into other memories and stories about the environment around it. It's difficult to imagine any sort of storefront laying fallow like that for that long; a place that generations

of young people could peer into and swap stories about another time in L.A.

Some years back, I slipped, through, what you could call, a "fourth wall" of journalism. I had been reporting a story about an initiative launched by Los Angeles Public Library called "Shades of L.A." It was a roving photo project—the brainchild of the former photo collection librarian Carolyn Kozo Cole—meant to create a more inclusive look at historic Los Angeles neighborhoods by targeting various ethnic enclaves and canvassing communities for their support. On select weekends, neighbors were asked to bring their family albums, scrapbooks, and shoeboxes full of photos to their neighborhood library branch. These were the years before smartphones and easy scanning, so a mobile studio was set up in a corner or back-room for a photographer to capture images of the images that would become part of the library's holdings.

I was so taken by the event, the *bonhomie*, that after I'd filed the feature and it went to press, I volunteered to assist with the project: precisely, I wanted to sit on the other side of the table and ask questions about the histories people carried in with them. As much as the photos enchanted me, it was the storytelling that pulled me in deeper. People who lived in these beautiful old neighborhoods over the bridge, south of the freeway, who hadn't seen or spoken to one another in years, sometimes decades, shared detailed anecdotes and memories prompted by the photos spilling from old grocery bags and hat boxes. They filled in blanks of family stories: They remembered the old mailman's name, the movie house on the corner, where the old L.A. Railway Yellow Car stop had been. They knew what used to be under our feet, what had been across the street. They told these stories with relish and laughter that made their eyes water—a mix of emotions, I was sure. This was life within "red-lined" L.A., the Los Angeles of restrictive housing covenants and veiled discrimination. Limited to certain neighborhoods because of religion or color, Angelenos gravitated to specific, more welcoming, areas of the city. Pushed into the periphery, to the edges of booster-touted Los Angeles,

they chased their dreams; they found plenty.

I was hungry for those stories, those histories, the ones that were van-
ishing with the modest single-family dwellings bulldozed to make way for
multi-unit apartment complexes, that then gave way to row upon row of
mimeographed-appearing condominiums, that blur into the landscape.

These stories prompted by photographs, from nieces and nephews,
great aunts and cousins, reanimate a very specific Los Angeles, noun by
noun, adjective by adjective, sentence by sentence. Here was my Lost City.

A gain, I ask myself: Can it be nostalgia if it isn't your personal memory?
 That yearning is a different sort of longing: It's a reaching back for
context and one's sense of place within it. As I witness the city's transfor-
mation, I keep asking myself what I need and why. What pieces of this built
environment are important to my story? What do we as Angelenos lose with
that ever-pressing quest for "progress"? What fuels that jones to persistent-
ly, drastically "remake" our environment. To try again?

In the market-driven transaction of gentrification, people and their sto-
ries of how a place came to be. What residents lost and what they gained and
all that happened in between. This is why, perhaps, I stare so hard into the
frames of my own family's old photographs, to see what I may have missed
within the edges of the environment: the flowers in the beds, the trees
framing the porch, the hand-painted signs on shops in the near-distance,
mom-and-pop operations lining the street, standing shoulder to shoulder. I
wanted, *always wanted*, to understand more of the story of this place, what
it was, whom I would see on the street, what languages I might overhear.

People ask me why I take photos of buildings, streets, and curbside still-
lifes; odd clusters of detritus. Tangled gardens. Worn-down sidewalks. Make-
shift-altars or faded memorials. I do because I fear there will be few records
of this—the incidental and idiosyncratic markings of real neighborhoods that

make place a place. The selfies of this generation tend to obliterate context, the details of specific location. Why don't we look out on the environment? Is Los Angeles simply a location—rebuilt over and over—to stage our lives? Not a place, these images might suggest, to actually *live* in?

WHAT IT WAS / WHAT IT IS / WHAT IT WILL BE

Gentrification begins with words. Language of erasure.

There used to be nothing there. . .

That place is a ghost town after dark. . .

No one goes there anymore. . .It's no man's land. . ..

How charming is this? Why doesn't anyone know about this neighborhood?

When I first hear those statements, I cringe. But the initial blow, the uncomfortableness, evolves into an active solution.

I have begun fashioning retorts:

There has always been something—and people—there.

Have you been after dark?

The people who live here, do. Now, so do you, so shush, don't ruin it.

Language is gentrification's first salvo: It takes the initial swing, dismantling place as it once was. Words like "discovered," "unearthed," "lost," and "found" are fraught. They most always elide the story of the people who for generations have made their lives within these bounded territories, those "clandestine" neighborhood outposts. Ethnicity and race are bound up in this; so too, class. It's no coincidence that the neighborhoods often on the shortlist to be "remade," "rejuvenated," or redeveloped once had been deemed "undesirable"—or simply "scary." Now, in Hollywood's indubitable way, they have been deemed ready for their close-up.

Gentrification—the word itself—is a mouthful and a Rorschach. And, depending on what side of the line you stand, it may be your resurrection or your ruin. It's been a word brandished so frequently of late; its meaning has essentially become a wash of raw emotions.

Recently, I was making my way through a feature story in which a woman was asked by a reporter about how she felt gentrification had shaped her neighborhood, *"How has it affected you and loved ones?"*

"I don't know what gentrification means," she replied without affect. "But I know what displacement means. I know what it looks like."

We all do. In large ways and small.

Luis J. Rodriguez, poet, novelist, and memoirist is sensitive to the language of erasure—its power and reach. "My first house I ever owned was in Highland Park—it was still the barrio," he recalls. "Avenue 57 near York. I would go to the panaderias, go to the taquerias, the botanicas, the carnicerias. Those were the neighborhood shops. Go there now, and there are boutiques and cafes—and it wouldn't be so bad, except our people aren't being included. That's the thing. That's the thing. It's nice that they are fixing it up, but why are people gone, and *then* they fix it up?"

These are the important nuances of the story that tend to slip away. Embedded in this notion of "rejuvenating" or "rehabilitating place" is an implicit bias. That "upgrade" or "recasting" tends to excise the bustling way of life that already exists.

Not everything makes the transition: What happens to the sandwich stands and the greasy spoons that have no such chance of being resuscitated, creatively repurposed into some sort of theme-y dive that pretends to be what it erased? What of the places that used to be the sites of

union organizing, or neighborhood ESL classes or backroom outposts for college tutoring? How about those cheap, dimly lit spots where community organizers could meet over a cup of coffee, toast, and over-easy eggs and joke about solving the problems of the world? As a journalist, I would slip into these distinct realms: Meetings where people talked not just business, but connected serendipitously and hatched a new scheme or the solid outlines of a plan. In a city where the perception is that no one walks, no one "casually convenes," chance connections indeed transpired—formalized—in places that were part of the very fabric of a community. These were the homegrown spots where you knew you'd get your news and your bearings.

Recently I found myself sitting at a long, festively appointed table, listening to old-school Who-Shot-John? stories, shaggy dog tales of the sort I hadn't eavesdropped on in decades: That cafe and barber shop talk that you just have to wade into and catch up. I was a guest at a reunion of the Eastside Boys and Girls, a group of (mostly) African American Angelenos who grew up during the '30s through the early '60s in the neighborhoods bounded by Main Street on the west, Alameda on the east, Washington Boulevard on the north, and Slauson Avenue on the south. "Block by block, year by year, Blacks expanded their boundaries southward along Central Avenue," wrote Erin Aubry Kaplan in a 1997 *Los Angeles Times Magazine* cover story about the Eastside Boys and the evolving black community of the time. The Eastside was a mix of natives and migrants, who worked in and around Los Angeles's de facto segregation.

It may have been a "make-do" situation, an island born of racism, but many Eastsiders look back at that moment as sacred, protected space: Eastside Boys founder Hal Miller told journalist Kaplan: "There was no caste system. Everybody knew everybody and they lived together. Doctors, lawyers, butchers, domestic workers. You didn't have a chance to commit a crime. The old ladies would be sitting out all day on the porches snapping string beans, yelling at each other across the street, telling each other the news."

It's been eighty-plus years of celebrating, strategizing, and shooting the breeze, and this once-a-year affair is a red-letter day on the calendar for many—the event pulls what feels long-lost back into sharp focus. Sadly, what also becomes clear is that these stories of an era go with them. If they leave out one anecdote, one location, it will become part of the rubble of lost memory.

The afternoon expanded in a way these affairs tend to do, both slowing down and opening up time. And while the dance floor doesn't quite fill up like it used to, I was told, the lobby was a maze of wheelchairs and Rascal scooters, and the conversation at a steady roar, and the great jazz singer Barbara Morrison was bending the blues into different tempos and hues as shoulders rolled and shimmied and memories took flight.

You a writer? someone asked.

And then another, *What's the use of all these old dusty stories, girl*?

Their city, the borders and boundaries, their very sense of it, is all but gone. But that city came alive with the memories of coordinates, addresses, boundary lines, renamed neighborhoods: the dances, the jam sessions, the late-night drives, even the misadventures. ("Now who used to drive around in that hearse? Didn't he take his date to the prom in that car?") So many anecdotes, prefaced with the clause, "Maybe *you* remember. . . ." In the middle of a story enumerating the many amenities—clubs, boutiques, professional offices and movie theaters—in their old stomping grounds—my host, Lee Young, a Los Angeles High graduate, paused, leaned across the table, and in a stage-whisper confessed: "I was a person who got around town *entirely* by landmarks. All my landmarks are gone. I'd be lost at home." His chuckle underscores, not so much a resignation but an amplification. "This is why I have to use the GPS all the time now."

He had often seen her laugh at herself, what was more, he had seen her laugh at her dreams.

—Nathanael West, from *Day of the Locust*

LOST / HIDDEN / DISCOVERED / FOUND

For the last few months, a childhood friend has been sharing photos of a view from her home window. Not a seascape or mountain ridges. Something that would seem at first glimpse mundane if it weren't meant to illustrate something else entirely. She updates the Facebook post with a new caption and photo as needed. It's odd to be looking through a window onto her window in almost real-time. Early on, the view opened up onto just a cement square of foundation, then the wood framing. But in no time, it seemed, the spaces our imagination were filling in. Gone was her view, albeit distant, of the glimmering line of ocean. The palm trees, the stucco roofs—all gone.

"My neighborhood is becoming overbuilt," she lamented, "Today I'm watching cement be poured from a crane. There are five cement trucks lined up on the street. This building replaced single-family homes. Traffic has increased five-fold and the building is continuing."

One commenter sent condolences. Another commiserated: "Makes me sad that L.A. isn't the same 'town' I grew up in." Still another offered context: "I don't like it either but that's politics and land developers funding it. L.A. is just a place for me to visit, not live anymore. Too many people and the traffic—awful. My solution—move far enough away where life is less populated—for me it's about the quality of life."

I pushed away from the screen, closed my laptop and wondered to myself: What is the solution if you want to stay?

There are too many versions of this story circulating. Longtime residents, wondering after their Plan B, C, or D; people running out of money, running out of possibilities. These tales of shifting place seized space, affordability—both from young and old—have almost surpassed traffic woes. I can't seem

go a day without hearing some a story about seized or disappeared space.

I hear the words, *gentrification, pushed-out, density, hipster* on a near-daily basis. None of it is positive talk—but most of my friends are natives or near-natives (longtimers who remember no other place as home). These stories fill my social media feeds. I hear snippets of conversations at gatherings—much like the one at the mixer—where people are being worn out or run out. I've felt a rush of tears as well as I have listened to the ugly contours of a familiar scenario of being priced out or the force-outs that come with urban renewal or as one developer termed it "value-accretive improvements." One story, heavy in its consequences, now frequently comes to mind: A woman whose voice caught, then shook until it curled into a whisper, as she told the story of her family moving to the desert—unable to hold on to the family home, unable to hold onto Los Angeles. 'We just can't. It's too expensive. "What will I do without my family? What's the point without your family? What's home without your family?"

We all know—and often joke (albeit cynically)—about the outward indicators that alert us that change is in play: the horizontal-slat-wood fences; the sans-serif numerals in brushed steel that house-flippers affix to rehabbed homes; craft coffee; young women jogging in fancy workout gear at night; the dog-walking, new neighbors who won't say hello; the small gallery or performance space. All of it abruptly announcing—your "sleepy" hollow is now tagged "it"—has "come into its own."

By the time those entities arrive it's usually already over, journalist Peter Moskowitz demonstrates in his book: *How to Kill a City: Gentrification, Inequality, and the Fight for the Neighborhood.* These details and additions are certainly signs of gentrification, he writes, but he makes clear "not their causes."

For weeks now, I have been toting this book about as if it was a field guide to new terrain, or more specifically, a necessary handbook explaining the injuries and symptoms affecting my own city. I'm looking for prescriptives:

"Gentrification might seem rapid when you're in a neighborhood experiencing it first-hand," Moskowitz writes, "But really it is a long-game."

The pushback isn't simply against the visible, itemizable changes; it's not just the baristas, the dog-walkers, the brusque or aloof shop owners, the developers and the realtors—it's capitalism. So not only does your neighborhood go, but with it, Moskowitz asserts, so does your investment and presence in the city and on a place.

Not only does your neighborhood evaporate, I've noted, but your mark on it. Your imprint.

"SO WHEN THEY PUSH, YOU PUSH BACK HARDER"

The words are listed on white boards and on tear-away butcher paper. All over the city. Bullet points. Prompts. Inquires. Questions currently moving through activist circles at meetings and "actions":

How do you want to contribute to your neighborhood?

What role do you want to assume?

One person's "blight" is another's ancestral home; one person's renewal, is another's erasure.

On what side of history do you want to stand?

I've been sitting on front steps, at kitchen tables, in hot living rooms cooled only by a breath-of-breeze generated by delicate plastic hand-fans. I've been gathering anecdotes and testimonies about usurped blocks, nightmare landlords, and most troubling, seniors suffering from a condition called "root shock." In other words, as families lose homes passed-down generations, they don't just grieve a structure, but all that is familiar surrounding it: longtime neighbors, trees, routines, scents, and sounds.

There's mounting push-back: I've learned of informal middle-of-the night bike-ride campaigns threading through L.A. aimed at grabbing "We Buy Houses for Cash" placards from off-ramp fences and light poles and turning

them in for bounty. Anti-gentrification flyers paper walls and windows of businesses in rapidly gentrifying Highland Park—their messages sail straight to the point: "YOU are the reason my mother, brother and sister were displaced three times in the last two years."

One organizer tells the story of a door-to-door developer, returning like a ghost, inquiring about her neighbor's falling-in-on-itself home in Mid City. "She said 'no' three times. He kept coming." The fifth time, her neighbor acquiesced. "He's slowly buying up the block, one by one by one," she told me. "Now, my friend says, he's made it all the way to her new neighborhood in Jefferson Park. Knocking on doors making offers."

As land and homes are snatched up, one by one by one, or banners reach across construction sites, promising (or threatening): "There's a new neighborhood coming to town." Angelenos ask themselves: How do you protect not just a neighborhood's unique character, but people and their imprint, their story, and their struggle?

As a new member of a community—a renter, a business owner, a student, an artist—how can you work to not be complicit in a cycle of displacement?

And I keep thinking, for all of us: *How do you want to contribute to the story of the city? How do want to influence and shape history?*

What activists have been asking more frequently is, how can we all best support communities in the crosshairs? Especially those communities most vulnerable to losing their hold. Their legacies.

This is another, to use Moskowitz's term, "long-game."

But sometimes, we are all now learning, the funky boutiques and the dog parks, can be red herrings, to distract from larger re-imaginings at work.

They speak to a deep and painful history of place in inner cities—of abandonment and benign neglect, and now, of over-anxious reclamation.

Case in point: A woman in an elaborate headwrap and crisp black-and-white Chuck Taylors seated next to me at a recent South L.A. anti-gentrification roundtable, rocked with electric impatience as the talk of displacement

mounted. We listened to testimonial after testimonial; grievances stacked up, one atop another, until, I could feel that she could no longer hold her fury.

"Fuckin' Dunkin' Donuts just now went up into my neighborhood. A fuckin' *Dunkin' Donuts*." Her teeth snapped into the taut skin of a just-ripe nectarine, the sound loud enough to provide ample punctuation. "I've been living in South Central Los Angeles for I don't know, like twenty years. Ain't seen no white people. Now I see Dunkin' Donuts *and* white people." She stopped only to take a quick breath, "Used to be if you wanted the police to come to check out a burglary, robbery—anything—you had to make sure to tell them when you called: 'I'm a student at USC.' Only then will they come. So I know what the Dunkin' Donuts means." She shifted back to the center of her chair, then leaned over into my space, her voice dropped to barely a whisper. I don't have to hear the words to know her thoughts: "Here comes the neighborhood."

Skila Martinez, the curator who runs Cielo galleries/studio, the space hosting the afternoon discussion, rose to address the audience and to consider her role and that of the complex. The convertible rooms are housed in a collection of nondescript warehouse spaces that she's careful to keep as low-key as possible. The goal: To be at one with the neighborhood; a boon, not bad luck. "I don't want to put anyone in danger who lives around this space. I want this to be a safe space and to protect the community around it." She was frank and transparent about the consequences of art moving into vulnerable neighborhoods, uprooting residents who no longer "fit" with the new vision and intentions: "When white people start coming into these communities that have long been communities of color, the vibe changes. The police come to protect *them*," she addressed the ethnically mixed crowd. "*That* is privilege. That is what privilege looks like." This isn't baseless worry; it is a pattern repeated time and again, she explained. "And I want to keep this a safe place for the people who live outdoors here, the families who do their shopping, and the drum circles who come together. They've been here

for a long, long time. I'd move somewhere else before I'd endanger them."

For many, true refuge in the city is difficult to come by. Years ago, I entered the Mid City home of the actress Frances E. Williams. She was, at the time, playing the role of the wise "waitress emeritus," Miss Marie on the short-lived television series *Frank's Place*. As instructed, I cleared a place in her breakfast nook while she made waffles from scratch on her worn, white stovetop: "Langston Hughes once sat in that very chair," she announced from the stove as I flipped open my reporter's notebook. "So did Paul Robeson," she punctuated with a raised brow, and made sure I was taking notes.

Williams had been on my radar, not simply because of her acting (her resume included work with the director Oscar Micheaux—the first major African American director—as well as Charlie Chaplin), but because she had a deep history in both activism and community organizing and, consequently, became the first black woman to run for the California State Assembly in 1948 on the Progressive ticket. I was gathering background for a story about little-known or lost narratives of Los Angeles, but our intended conversation veered onto a related but much more onerous, side path after my eye fell on a piece of paper in a stack of other mementoes from an earlier time: it was an old deed, a document, she felt really told the true story of Los Angeles:

> . . . *no part of said premises shall ever be leased, rented, sold or converted to any negro, or any person of African descent, or of the Mongolian race, or any race other than the white or Caucasian race.* . ..

That day, Williams said she'd saved this old and faded souvenir of enmity, because she wanted to remember that really she was *not* supposed be here—but here she was, in a beautiful postcard-worthy neighborhood that then-and-now flew under the radar. She didn't always feel safe. Not early on. It was the early 1940s, and it was dangerous living within a section of the city

under a restrictive housing covenant. "When we bought this house," Williams told me, "no blacks could live here. My husband, who was a ceramicist, tried to get a garage at Arlington and Jefferson to work in, and we couldn't *rent*. I had to get a white friend of mine who was an artist to be the renter so that my husband would have a workplace near home."

It was happening all over: Jefferson Park, Hancock Park, West Adams. She'd caught wind of families' struggles in Leimert Park, and by now her personal experience had invigorated her; she pushed back. "I created a twenty-four hour patrol. I had men available to go and protect those homes blacks were buying. People would throw in dead rats, flood the basements—everything you could think of doing, they did."

This was a familiar story of how African Americans found a way to write their own rules and create their own safe harbors. Marked by this experience, Williams went on to work as a housing activist, a member of the Homeowners Protective Association, organized by *California Eagle* newspaper editor and publisher, Charlotta Bass. There were many, many other multilayered stories like her own, about how people made their peace. She wanted to protect them and their experiences: "And so, how does that make me feel?" She considered the yellowed document. "Well, when they pushed, we pushed back harder. We all gave up so much to be here."

I'm thinking about Frances Williams and Lee Young and Nancy Uyemura, and my friend Inez as I slip into the Last Bookstore downtown to hear journalist Peter Moskowitz talk about gentrification and the health of American cities. I drifted in a shade before seven, thinking I was early. I was sobered by what greeted me. The size of the crowd spoke volumes. People filled all the scattered second-hand chairs; they leaned on or crouched between bookcases. Even the upper-tiers were packed in; standing room only. More than four hundred in all, so crowded that management stopped granting entry. I'd

made it just under the wire. Several interested friends found themselves snared in the line outside. "I can only let you in if someone comes out," the line monitor told one. Another texted: "OMG! who r all these ppl???"

I had to wonder. The "gentrified"—those pushed out—looking for help or strategies? Or the "gentrifiers"—the new arrivals—seeking absolution? Looking around the room, the scale seemed to be tipped toward the latter.

"No one is here because they are neutral," said the young woman who slid over to make space for me on the polished concrete floor. "It's not a topic about which you go 'meh.'"

While Moskowitz doesn't tackle Los Angeles head-on within the pages, profiling instead the evolution of four very different U.S. cities (New Orleans, Detroit, San Francisco, and Detroit) through varying stages of gentrification. The talk and brief Q&A, led us all through all-too-familiar territory: Displacement and replacement of the poor for profit; the lack of protection of citizens and the history of red-lined neighborhoods (those territories where services, loans, insurance, *et cetera*—were denied based on racial or ethnic composition); the families like the Williamses who had worked creatively around covenants, and now, decades later, find themselves in the site lines of developers. When they go, so too the nesting narratives, rewritten without a trace. It's no coincidence that those economically depressed, or old red-lined neighborhoods have become targets for gentrification. They are not just "cool"—they are now profitable.

All of those high-end tchotchke shops, the upscale restaurants, the fancy Pilates studios, most of us walked by (or in and out of) to get here this evening, says Moskowitz are part of a larger design: "We are being taught to consume a city, not experience it like a community."

"HOW MUCH LONGER WILL IT BE LIKE THIS, LIKE THIS. . ."

A hideous listing popped up on the online classified site Craigslist a few months back; the sharp hit of smugness leapt from the screen. The posting advertised a room in a house for let. $590 a week. Yes, a week. That alone would have seemed questionable enough, but the listing's very tone took it to a different level: The homeowner referred to the neighborhood as "BoHe" and lauded praise mostly on its *adjacent* location, followed by his notion of amenities: A "5-min and $5 Uber ride to downtown and the Arts DistrictThis is primarily a Latino neighborhood and it's in the gentrifying BoHe/Boyle Heights area with artists, hipsters. A neighborhood with locals and Taco stands on every corner."

The post sent up a wildfire of response. It didn't last two full days before the original poster took it down. The discussion, however, churned on for days and days (along with the resentment)—as Boyle Heights had taken the spotlight as a neighborhood that had shifted into full-on resist mode—by any means necessary.

Mr. BoHe troubled the raw nerve. Still predominantly Latino, Boyle Heights has had a long, proud history as one of L.A.'s most richly diverse neighborhoods; early in the last century it was home to a mix of ethnic communities—Mexican American, Japanese American, Jewish, and a smattering of African American households. And while much has changed over the decades, the community remained, in the city's collective imagination, a living model of Los Angeles's unique, if sometimes complex, coexistence.

Protecting this sense of home, a place hard-won, has been paramount, says one longtime family friend who spent her early years in Boyle Heights. It was the neighborhood, she says, that most shaped her *and* her idea of what it was to be an Angeleno. "It's a neighborhood that people have always been ready to go to the mat for. Honestly, I can't remember when it wasn't."

But the mat—and the target—keep moving. Leimert Park, Highland Park, Echo Park, South Los Angeles—and the long battle for Boyle Heights, are all

on the table, all in the redevelopers' sites.

———✳———

"At the heart of it all," says James Rojas, "it's about belonging." An L.A. native and an urban planner, Rojas grew up in this neighborhood in the '60s and '70s. He frequently leads students, teachers, urbanists, historians, and journalists, like me, on walk-throughs, training our eye on environment: we look at spatial configurations, how territory is managed and marked, we discuss the role of ritual and over-the-fence conversations. These pathways consider the importance of proximity, there are places to pause and to commune—all features of what he calls Latino Urbanism.

The morning of our latest walk is quiet, just before the bright blade of heat will set in. A long banner—"*Alto a la gentrificación/ Un Boyle Heights/ por Boyle Heights/ Para Boyle Heights*"—stretches across the upper reaches of the old brick building that's still referenced by longtime locals as "Hotel Mariachi." The Boyle Hotel, built in 1889—where working mariachis took up residence—some seasonally, some year-round—is now an affordable living complex. Like so much else in this neighborhood, it is also contested territory. When renovations were made in 2011/2012 to clean up and upgrade the living spaces, the reopening and the very definition of "affordable" stirred up controversy: "I feel deceived, defrauded, and sad at the same time," one musician told the *Los Angeles Times* shortly after the remodel. "In reality, this was for my children, not for me."

Property value spikes and rent hikes in the neighborhood have made what was already challenged ground, more so. Well-organized, high-profile protests and actions push against new outside businesses—they have shuttered galleries, spooked "prospectors." Graffiti warning "Take it Elsewhere" and "Fuck Art Development" unambiguously marks territory.

Indeed, as the Arts District's development moves east across the river, and with it a more aggressive threat of gentrification (new galleries, living spaces,

and businesses)—the texture of the neighborhood already feels different to those who have known it from the inside out. Like the Arts District without its artists, the old Mariachi Hotel and Plaza and the district surrounding it, could as well be emptied of the musicians from which it derived its name.

When Rojas lived in Boyle Heights, the property across from the hotel—now the site of the Gold Line station and where the elegant kiosk and stage rises—was a community hub: a bus stop, a gas station, a doughnut shop. "The people in the projects used to shop here; now it's more of a symbol. It's designed to be a landmark, but you don't *use* a landmark. Not in the same way."

We walk past the mariachis looking for work in black charro slacks seamed in silver braid and shimmering buttons, their crisp, folded jackets draped over one shoulder, then thread across the street, past where the Aliso Village housing projects once stood, and then sink deeper into the neighborhood, past old bungalows and cottages and duplexes that, for me, are—even still—the most evocative display of old-Los Angeles architectural styles. Still there are tiny markets stashed mid-block, festively appointed front porches lined with bunting and a series of handmade altars. Women trail steel shopping carts and baby strollers, and Rojas makes a point to speak to each and every one.

Much of Rojas's work centers on trying to imagine and inspire more welcoming, people-friendly environments. He believes deeply in the well-being of neighborhoods. In workshops he leads cross the country and around the world, he asks grownups to build a favorite childhood memory—in wooden blocks, Legos, plastic trinkets. He's interested in what doesn't show up as much as he's interested in the important emotional touchstones: "I see more trees, plants, flowers rather than things like freeways, or even houses. From a child's perspective, you're interacting with a place—what makes place a place—and the people in it."

This sort of storytelling, explains Rojas, is a problem-solving tool: "From this we can see what really matters to people in neighborhoods, not some

urban planner's idea of what people need—*put a bench here a park there.* We planners must be mindful of individuals and their needs. People attach to places differently, and you have to have a strong social network vested in businesses and the neighborhood. This is how people form memories and their stories. That's what's so painful. It takes years to develop this sort of close-knit social connection. I miss it. All of the improvements are very value heavy. *People* get pushed out of here. And so, we all live in these memories."

"FRILLS"

> *If we all conceptualize the reality and the possibility of the city uniquely how can we be on the same page when it comes to building an equitable future In this way gentrification suppresses and displaces memory, and makes it harder to build lasting justice.*
>
> —Peter Moskowitz

My friend Victoria and I make a plan to visit her old apartment building, a beautiful perch overlooking Echo Park Lake. My old neighborhood. We are to meet up with her former manager, Aya Seko. I'd been looking to speak to someone who was knee deep in all of this, someone who was monitoring changes—the revolving door of populace—but from a different point of view.

The city's annual Lotus Festival will kick off in the morning. So right now, the park and lake look exceedingly seductive in the deep-amber afternoon light. I note, among the healthy luminous lotus blossoms and honking ducks, more than a few new additions: children casting fishing lines at the east side of the lake with the help of Mountie-hat-crowned LAPD, some newish sculpted shrubbery spelling out the words "Park Proud." Frills, as one gentleman, a longtime resident, pointed out. "Almost too many frills."

Beyond wariness, I wasn't sure what feeling was welling up inside.

Memory is a strange house. Doors or hallways leading to the past don't always open onto something familiar. They can trick you.

On our walk over, I'd made note of some of the businesses that were now occupying my memory of old storefronts. In their place stand new theme-y, high-concept pubs, and restaurants with taglines like "a Brooklyn vibe on the Eastside." The neighborhood is in that phase of the past and future crossing—the present harder to discern. I recognize enough boarded up and shuttered businesses with signage still in place to know where I am, but the present is looking like much of L.A.—austere cafes and high-end restaurants with one word names or a cluster of words (or elements) distributed within Crossed X logo. And lots of sleek lines, glass and steel.

What's so puzzling—no, infuriating—about the new details, the "frills," is the impulse to erase and transform place. My friends and I often chose neighborhoods so we could experience a little bit of that flavor, that point of view (at least what was allowable; what we could earn in time and in fellowship). We looked for places we felt in sync with, or, if we were lucky, would ultimately sync up with. We tried to adapt to neighborhoods, not alter them to fit our goals and needs, not force them into our vision or some of-the-moment trend. If there were problems—and they popped up time and again—we tried to work together to solve them. I shopped and ate locally at the longtime spots. In springtime, I watched the young men—with dark, glossy hair, dressed in gray sweats, punching at air—take their laps around the lake, training for fights. In summer, on a whim, we walked to Dodger Stadium to see what seats we could score last minute. Ultimately, I suppose, I wanted to be like those tumbleweeds that used to skitter down my old hill, to pick up a piece of this and that. Add it all to my journey.

Aya says the only real power she wields is focused on trying to make decisions about who might be part of the mix—diversity of ethnicity/race/class, all come into play. That's getting harder and harder to do, of course, with increasing property values and income caps, but it is something she

thinks about always as she wades through applications. "When I speak to potential tenants, I want to catch them one-on-one, not in a crowd. I want to get a sense of who they are and how they'll fit."

What attracted her to this place, and what keeps her here, has much to do with its aura and the people. Its history of working-class families, of racial, ethnic, and class diversity. The Echo Park she arrived in is much different from the Echo Park I left. And the Echo Park she currently moves through bears very thin resemblance to the one I yearned to move into twenty years ago. But unlike the woman I'd encountered at the speakeasy mixer, Aya wants to pay respect to the history that pulled her here, the elements that made her know that Echo Park would make a commodious place to call home.

She feels the strain, the tension between the coming and going worlds. She sees who is and who isn't stopped over a "suspicious" open container—*not* the skinny jeans guys drinking Pabst Blue Ribbon near the boathouse. She sees who now jogs around the lake at night in fancy athletic garb, and who still waits in the half-light of morning for the crosstown bus traveling the length of Sunset Boulevard. You don't even need a beautiful perch to see that.

That evening, fueled by our conversation, I finally summon my nerve. I make that familiar slow ride up Sunset Boulevard, east, toward downtown, to address unfinished business. The sky is a maze of construction cranes, a current and ubiquitous feature. So much so, that when they are gone, I will most likely retain some sort of ghost image of them, climbing into the sky. In my whole lifetime here, I've never seen so many cranes, booms aloft. I take the left in front of the landmark—a furniture store—I used to toss out to everyone who was looking for my small strip of a street, but it too has recently shuttered. The signage, though, still lingers. I know not for long.

As I lurch up the hill with diminished expectations, I take a cautious look. Two huge condo buildings—one dung brown, the other dry-weed yellow—in places where there had been single-family homes, an empty lot and modest triplex, respectively. My old building startles me. Formerly a standard-issue, modest dingbat apartment complex, white with black accents including the blocky numbers spaced across the front. Currently out of the concrete rises a big, bright, tangerine-colored box. The address is now in brushed-metal Arial font, and below it is a sign directing any inquiries about these "townhomes"—not to a person, but to a now fancifully named business concern/LLC.

Of course.

TAKACHIZU

There is, at times, a slow, a natural giving over of space, an evolution of a neighborhood that transpires over time. I see this less and less in Los Angeles.

I am sometimes astonished by what I might turn a corner onto; a chance encounter with some extravagantly rendered, but now-faded or collapsing wood-frame structure dating back to early last century. They *are* there. Evidence of the past. Of who we were. It's just becoming more difficult to find.

My parents' old neighborhood in Southwest Los Angeles flew blissfully under the radar. Consequently, it has eased through a very slow unfolding and evolution. It is a vivid time capsule of mid-century L.A., but its time is up. My friends and I grew up there; made new friends and lives, then moved away. Some returned and raised their children in those houses, others rented to family and friends. The architecture was altered only to shore-up wear, or perhaps to open up the kitchen, or re-do the old "rumpus room" into some more modern amenity. I marvel at the late-Fifties serpentine pool-slide whose apex I could still discern, even from the street, behind a fortress of

ivy. The change I saw coming a few years ago. Yes, the walkers and joggers, first. Then our street appeared in a late-night comedy short (probably scouted by one of the walkers or joggers). It was surreal to watch on a loop, this off-the-beaten-path street made up of Jewish and Asian American and African American families, suddenly the backdrop for some skateboard stunt.

It's seldom just one thing, one instance that informs you that what you know of a place, and how you understand it, is over—that it's really no longer "yours," no longer the place for you to make new memories.

Object lessons land sometimes out of nowhere. I was packing up my parents' house. Forty years building a life, creating a story put now in boxes to be trucked off. In other words, I was deep in the latter stages of saying goodbye, thinning out what was left of home. Last fall, I was at a critical stage, arranging books and records and various keepsakes for archive donation within the hatch of a car, winnowing away memories.

A woman I didn't recognize was standing in the steeply pitched driveway of a house across the street, the front door ajar. She rushed across the asphalt, angling toward me, then jammed her hand into mine. The pumping handshake seemed to energize her; her monologue drifted over how much she simply had to do: The electricity, the pipes, the floors, the backyard, the garden . . . she ticked off the list. From this, I came to understand, that she was the new owner.

She didn't ask my name, nor did she inquire about what I might be doing with a dolly and piles of old records, books, and tapes. She didn't ask if I were moving out or in. When a pause opened up, I offered that I'd lived in the neighborhood for years, my family, had in all, lived here more than four decades. She didn't ask about the family whose house she was remaking, not the architecture, nor the adjacent neighbors. Neither did she inquire as to what it might have been like to live here all those years. Who was left that she could talk to? What about the ground's gardens? Terraced and lush—a blaze of magenta and hot-pink bougainvillea, bottlebrush edged by ice plant.

Manicured dwarf Japanese junipers. This oasis was created by the man who landscaped several freeways around the city, whose garden represented the mood, the very scenery along the strips of wide, fast-moving roads leading in and out of this place.

I felt a flame of anger rise in my center. *How could she exhibit such disregard? How could she be so incurious?* I think about the entire struggle in this neighborhood, the hard-won victories, and the treasures.

That flame still uncurls. Catches me off guard. I can't seem to help it.

<p style="text-align:center">✳</p>

I realize, as I retell the story, that we all are carrying around stories, so many of us recovering from some sense of root shock.

"All of this is so painful. I think people are controlling what they can with protesting," Evelyn Yoshimura tells me. "It's a way to deal with all of this loss." We are sitting at lunch at a restaurant in Little Tokyo with Nancy Uyemura, strategizing, sharing stories of vanished neighborhoods. Evelyn is the Community Organizing Director at Little Tokyo Service Center, and while the center's work doesn't formally extend to the Arts District, they have been partners in protest and have reached out to assist.

More than a hundred years old, Little Tokyo, in downtown Los Angeles, continues to be buffeted by waves of gentrification, its boundaries frequently in harm's way. One of the projects that came out of this constant battle for place is called Takachizu—which was a temporary community show-and-tell and gathering space (that now exists online) that allowed the community to identify and reflect on that which is most valuable, celebrated, and in the most need of protection within the Little Tokyo community. It drew the viewer's' attention to objects—buildings, game pieces, maps, photographs—that were redolent of history and memory. "For example Second Street really changed when they took Weller Street out . . . Weller used to have all of these little hotels, residential hotels for low-income people, little restaurants

and shops—and that whole block was taken out. Lost."

For both women, life and work have been about identifying, collecting, and curating history and fighting for the story and meaning of place. Both of them grew up in neighborhoods near my childhood neighborhood, in contested spaces just like my family: Street addresses that had been difficult to access, hard-won and for which our parents suffered indignities—the small and persistent cuts we now call microaggressions: In other words, their Crenshaw District—their Los Angeles—is also mine.

"Where and when I grew up had a lot to do with who I became. I grew up in the '60s. I lived in the Crenshaw area. There's a block called Big Hepburn and Small Hepburn in Leimert Park, the Big Hepburn was two-story houses. Ray Charles lived there. Ella Fitzgerald lived there. Those kinds of people lived there. We lived on the Small Hepburn, but we had to pass it everyday to go to Audubon. So I used to hear Ray Charles's band practicing on the way to school. But I didn't think about it much then: I thought: Oh, that's cool." But there was an underlying story, that she would grow to learn, because of those same restrictive covenants: "We couldn't live anywhere either."

The climate and coexistence energized and politicized both of them in different ways. Evelyn became an activist; Nancy an artist, "a story-gatherer" whose public art projects include detailed collages of social histories of evolving neighborhoods. Since place isn't static, she tries to catch it, still the motion—fresh and vibrant.

How she'll memorialize this, this moment, is uncertain.

"We moved in 1984. The artist, Mike Kanemitsu, whom I was sharing a space with in Koreatown, knew about this spot," Nancy recalls. "I really loved that space because it was so huge. We had to put a lot of energy into preparing it. We installed walls. We put in the plumbing. We still have the receipts. Part of the deal was, we thought, if we'd put in this money in the beginning, when you passed it on, you'd get your investment back."

That didn't happen.

"All because of the different laws and ordinances and zoning," she continues, "is why we're in a gray area. So now we have to fight. At least for *something.*"

The Arts District Nancy arrived in was its own distinct orbit—it was then without a formal name. "It was quiet and grungy. With little pockets of artsy stuff." She sits for a moment, traveling back: summoning and laying down bits and pieces of memory. "On the first floor of the building there was a used-clothing boutique and a little cafe. It was called Big Bang. And there was only one little coffee shop down there that had been there for a longtime. There was a cappuccino wagon—trailer really. He'd come out evenings. It was precursor to food trucks," she recalls. "I'd run into Joel Bloom's market to pick up things. 'Heeeelloooo,' he always said in his big booming voice. It was also where I rented my videos. He kept a selection there. We walked around in those days—to places like Cócala for dinner or the art supply store, Roark." All and all, says Nancy: "It was gritty, but it really was not so dangerous. You wanted to improve it, but it didn't need to be high end."

But they were a community, bonded and solid: When Nancy had a cluster of bad luck—lost her job, Mike passed away, and she was diagnosed with breast cancer—her neighbors cleaned her home, readied it for her arrival, and checked in on her recovery. Nancy recalls, "What was really interesting was that we were really a community. Everybody came out and helped."

Much like its adjacent neighbor, Little Tokyo, the enclave endured its ups and downs. "The mid-to-late '80s was shifting, and was sort of good. But when we had the riots, it really went downhill, because downtown was getting really bad P.R. Nobody wanted to come down here."

By the late '90s, Nancy says, she noted another shift: "That's when we started getting those focus groups coming into those old buildings downtown, and they wanted to make them into little lofts."

That iteration was the beginning of selling the romance of a lifestyle—the artist *loft.* As a niche. A market: "They didn't get as far as us, yet," says Nancy,

"but they were coming. . ."

"And you know—just to pause a minute—you know what else was happening?" Evelyn interjects, leaning in: "Japan left. That money. It was kind of propping up Little Tokyo and had actually used Little Tokyo to enter the city of Los Angeles; it was only a few years after the war. But once they got established, they moved to Torrance because the property was much cheaper. And we felt that—its absence. It was a huge exit. All these empty storefronts. . .."

And it left Little Tokyo, like the Arts District, quite vulnerable.

"Did it happen quickly?" I ask.

No. Little by little, over time, you'd see the changes.

And then suddenly. . .

You used to be able to see the fireworks from Dodger Stadium.

The streets were pretty lonesome.

We used to have a gallery and shows downstairs.

We were a real community.

It was all past tense.

"I've been lucky," Nancy reflects, her voice steady, strong, and resonant. "Ours is not the usual eviction case in that we have a lot of space and not a lot of people filling up the place—ours is art and tools. And maybe . . . *maybe* this is where I get conflicted. I feel grateful to have had this place for so many years and have mixed emotions about what's happening now," she explains, "I believe in change and progress and letting go. But I also believe in acknowledging the past and saving certain things of value. It's really about balance and not trying to make a fast buck. It's also about how you value community and how you treat people. And in our situation it seems they don't even see us. It's like we are invisible. It makes you wonder if our lives have meant anything to anyone."

She doesn't recognize the people she passes on the street, even catching a quick meal close by feels like too much work some evenings; she feels more comfortable at home. "I miss those places like Gorky's and Cócala at

4th and Boyd." And while there are a lot more people in the streets," she says, "There a lot more people who don't give you eye contact."

How do we hold on to those treasures, in a living way, where the past can be an integral part of the present, a way to think about and shape the future? How do you protect legacies?

"It's like aging. And I've seen our community sort of gray, and there hasn't been a whole lot of new younger people come in, and you just sort of wonder what's going to happen. . ." Nancy's voice trails.

Evelyn only nods.

Nancy pulls out another tile of memory. An anecdote about a public art piece of hers that rises above the entryway of the community housing development Casa Heiwa on Third Street near San Pedro. *Harmony* is an eight-foot-tall hand-fan unfolded to span forty-four feet, covered in a mix of ceramic, aluminum, slate, and concrete tiles. Set onto its surface, Nancy placed a series of images of L.A. citizens interacting—the city's multiethnic community at work, at leisure, in ritual—together— treasures. "When we did the re-dedication of that piece, they wanted me to say something," she pauses, eyes wide. "I thought: 'Oh God, what am I going to say?' And then I wrote a poem, and I read the poem. I sort of sang a couple of lines from this Japanese folk song, and it has this melancholy tone to it."

Nancy stops for a moment and looks solidly into middle space, as if she is trying to summon the crowd. "And it just hit me. I said: 'But who will be there? Who will remember the words?'"

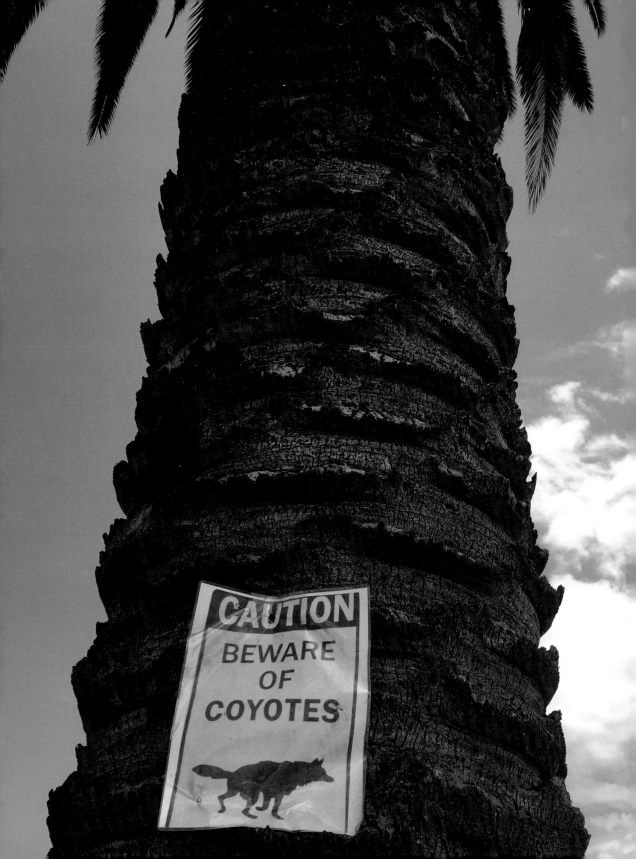

9 *Urban Wild*

. . .You could live here for years and never understand: Were you rural, industrial, or suburban?

—Robin Coste Lewis, from "Frame"

NO ONE REMEMBERS the intricate centerpieces. Not the handmade "natural" garland draped through the pine trees, or the gauzy, tiny paper lanterns. I'm not quite sure if the guests even recall the dress. There are no photographs of attendees ringed around tables set out beneath the generous stretch of an old oak tree's branches. Nor of the bride and groom gazes locked in the golden light. That's because those moments didn't occur as planned.

The wedding officiant had just bent back the spine of his book of homilies as the sun made its first soft dip signaling the last phases of sunset. Then came the smell, the telltale perfume—lemony but edged in a bitter mustiness. Strong-strong. Too pungent to ignore. We waited for it to pass, as if it were a loud sound—a heavy truck, or siren. We collectively held our breath. As the stink settled around us, the officiant plowed onward. Those of us clustered in folding chairs on the carpet of lawn, not so discreetly covered our noses, hoping it would pass, knowing it should. But it was a bad break that the couple had picked some over-active grove, some skunk hideaway. They just

weren't having it. Not today. They just kept sending up salvos until everyone burst out laughing, and the still-to-be bride and groom just cut their losses.

As I recall, we, as a group, decamped the beautiful yard at the beautiful house set against a canyon trailhead in Hollywood. After some consulting and dithering, we found someplace where a large party, of twelve or so, could push together some tables and order pizza and just say: "Another day."

My friend, the groom, would say years later, time softening the edges, that the experience was better than photographs. "You don't get a gift better than this story."

It makes for a very particular sort of only-in-Los Angeles anecdote. Like the coyotes that join in during Shakespeare in the Park productions at Griffith Park. Or the black bears that take luxurious swims on Indian summer days in Altadena swimming pools. While they are humorous incidents, those "Brights" that sometimes end our evening news, they are reminders that we share space, we coexist with environment we've attempted to tame, work around, hem in. We sent roads through, blocked-off passageways, clogged arteries here-to-there with our cars. But they remind us that they are here time and again. They force us to re-examine our own definitions of wild.

For those who consider Los Angeles from afar, its natural beauty, the wide-angle establishing shot tends to linger on vistas of our beaches and mountains. The "half hour from surf or ski" tagline sold the region for decades. These were the places we traveled to to restore balance. The coast *is* captivating, and the rush of glimpsing snow-capped mountains as I wilt in downtown traffic, doesn't fade—no matter how fed up I become with this place. But the encounters with nature we Angelenos stumble into or brush up against in our daily excursions are the ones that tell us/reveal to us more about the complicated coexistence we take for granted.

I have a stow of stories, some more embarrassing than others. Like the early morning run on one of those quick-to-ratchet-up, hot, Santa Ana-wind mornings. We—a running mate and I—are pacing ourselves up a gentle incline in Griffith Park. The sky is a canopy of neutral blue, cloudless. The yellow trail open, empty of other humans, but in the near distance we catch sight of an object along the edge of the trail, grayish, the color of lead pipe. I hear a sort of vibrating sound—the *ch-ch-ch-ch-ch*—that I associate with the memory of a chorus of lawns being watered at once. I say to my trail partner, "I didn't know they had put sprinklers in up here?"

"Um," she replies, slowing some, training her focus just a few feet ahead of us, "that's not a sprinkler. That's a rattlesnake."

We braked so fast that moment that we sent up a vast dust cloud. Now, standing stock still, we considered our options. The snake was coiled, which was why, from a distance, it looked to be simply some type of hose or duct— or a sprinkler jutting out of the yellow earth. Illogical, yes, but as I say to everyone, I'm city born, but wilderness raised. I learn with every blind curve and switchback. We backed away, and returned, very, very carefully, the way we had come.

My mother's term for the varying terrains we moved through on our way to visit her school colleagues in far-flung locales like Topanga or Tujunga, was "rustic." This was the late '60s and early '70s, and *rustic* covered a wide swath of unexpected environment that popped up on our city grid. Horses suddenly revealing themselves on a curve of blind road in North Pasadena. Chickens making a fuss in a backyard coop in East Hollywood. Peacocks strutting through Altadena.

When I moved to Echo Park in the '90s and my parents came by for their first official visit, I watched my mother give the roosters in the neighbors' yard a sidelong glance and, almost as a prayer, murmur "rustic." She was

worried about the uptick in street and gang violence around the city (as an LAUSD high school teacher, she'd kept up on the hot spots), but something about the roosters and the wild flora seemed to calm her. There was something about the balance that, I suspect, took her fears down several notches.

My neighbor, Joe, however, kept a pile of Xeroxes, pages of which he would affix to the neighbor's door. The flier's specific message was difficult to make out because of the multiple generations of copying, but you could discern a clipart likeness of the cartoon rooster Foghorn Leghorn, alongside some of the quoted sections of the city ordinances banning (or limiting—again, hard to read) roosters in residential areas.

Joe was a light sleeper with a hair-trigger temper and the birds would crow not just at sunrise, but repeatedly and on long jags, provoked or inspired by who knows what. Joe's patience had worn down to fumes, long before I had arrived. Some mornings, as I pulled out of the driveway on my way to work, I'd see him, his motions sharp and deliberate, shoving sheets of paper into the neighbor's mailbox or under the windshield wiper arm of all the vehicles marooned in the dirt patch that served as the neighbors' front yard.

One day, the rooster disappeared. I didn't confer with Joe, nor did he raise the subject. I also chose not to inquire after the rooster with the neighbors. "Better to be Switzerland," my boyfriend joked. But as cycles used to turn in that old neighborhood, the rooster was replaced just weeks later, by cackling backyard chickens on the property on the other side. And Joe? He threw up his hands and headed for senior living in La Cañada.

If I explain this coexistence to friends from afar, they are amused if not sometimes incredulous. When they arrive for a visit, they are stupefied: The raccoon that won't immediately let me pull into the driveway is such a frequent feature I've named him Otto. You can set a watch by the wild parrots that strafe the skies at sunrise and sundown at certain times of the year.

Coyotes roam our main thoroughfares—heavy with automobile and human traffic—not at dawn or twilight, but in the full light of midday. They loiter on corners, case backyards.

A former co-worker of mine, originally from the East Coast, told a story of a friend taking him around Los Angeles to show him examples of unexpected pockets of untamed Los Angeles, evidence of wilderness in the middle of the city. They went for a hike in Griffith Park to see the city spread out beneath them. They huffed and puffed up the grade, the carrot: the reward of a November morning, a clear uninterrupted, wind-scrubbed sky. But instead of taking in the expanse, the stretch of downtown to the ocean, he admitted: "All I could think about was raising my hand and calling out: "Oh, Taxi!"

You don't have to hike into the chaparral to get a glimpse of how things connect—how they were or how they got to be. I had friends who grew up in Compton around front and backyard "gardens", which really functioned as farms. This was decades before anyone was throwing around the phrase "locally sourced." You could go by their home for "supper" and out of the kitchen would float plates, platters, and bowls filled with the harvest picked and pulled from those plots just steps away: Tomatoes, string beans, lettuce, mustard greens. Bounty.

Horses here shared the road with cars. Grown men in cowboy regalia—hats and boots, shiny-studded shirts, and kerchiefs—towered over us. It's a Compton—with eggs, cows, goats, chickens—that even still, few know exists.

Richland Farms in Compton is a protected agricultural zone in a city now known in popular imagination more for the urban pulse of gangsta rap, and the gangs themselves. Like much of the region, Compton's demographics have reflected migratory patterns throughout Southern California. In the '40s and '50s Compton was predominantly white, but by the '80s, it had "turned"—as the elders around us used to say—a delicate and economic

euphemism for "white flight," leaving the area's population predominantly black. More recent numbers put the mix at sixty-five percent Latino and thirty-three percent black within a complex coexistence of cultures that mixes hobbyists with full-scale agricultural endeavors.

Through those shifts, Richland Farms has operated as protected space, a ten-block stretch that is considered to be the largest urban architectural zone in the Los Angeles basin. Its old-vine history sinks deep, in 1888 another Griffith, Griffith Compton, donated the land with one condition: that it only would be zoned for agricultural use. According to a National Public Radio report about Richland and its surrounding parcels: "In 1950, L.A. was the biggest agricultural county in the U.S. Today it is its most urbanized." That this pocket of Compton has remained protected and intact is nothing short of miraculous.

Outposts crop up where you least expect them. When we moved from the Crenshaw district to Culver City in the 1970s, the distance was no more than a fifteen or twenty minute ride, but it felt as if we'd broken through to some other county, if not another era. The neighborhood pocket we lived in, referred to, in some of the histories of this place, as "an island," was fronted by a freeway-speed stretch of La Cienega Boulevard. If you were headed north on La Cienega—Spanish for "desert marsh" (or as locals dubbed it "the swamp")—just beyond the neighborhood's formal entry on Wrightcrest Drive, was a set of stables obscured by thick shrubbery—ivy, bougainvillea, maybe even bottle brush, but memory fades here. I would sometimes catch a glimpse of the paddocks, or see horse carriers sliding into some hidden-to-my-eyes entryway. My friend Geri and I would sometimes go poking around near the perimeter to see if someone or something might meander out into full view. The odor announced that our eyes weren't deceiving us. Hay and fertilizer and something sharply earthy, something fecund that we couldn't

quite put a word to. It was off-limits to us, as far as I knew. I never marshalled enough nerve to just cross over and walk inside.

I would much later come to find out that Will Rogers, Jr. owned some acreage here on the hill, which was once part of Baldwin Hills. As neighborhood lore goes, Rogers's friend and colleague Ben Petti, who performed in films and Wild West shows and also trained Rogers's children to rope and ride, moved onto the this land and would later purchase the property for his family. The hills do indeed have rich wild history, with a chaser of Hollywood for good measure. A 1953 *Los Angeles Times* story reports that a horse got loose from its confines and went charging through the neighborhood, and was chased down Wrightcrest Drive—the neighborhood's main thoroughfare. The chase came to an unceremonious end, as the horse: "landed in an oil sump."

That sump would later become our neighborhood park.

Above and behind our houses was a stretch of rolling old oil fields, rich and still dotted by working derricks and rigs that cast strange silhouettes across the crestline of the hills, yellow-brown and crisp as old newsprint. Those shaggy lots housed field mice and foxes and jackrabbits and provided my very first experience with the aroma of skunk. It was rural and country. A literal outback just southwest of our home. My brother caught snakes along the shortcut through the fields above the park. Sometimes he'd snatch one hiding in our small yard just outside the kitchen.

Our elementary school sat atop land, facing Baldwin Hills (just above what would later become Kenneth Hahn Park). And it seemed as if every summer we'd have to keep an eye on those yellow-brown hills, well within the sightlines of our school and home, to make sure they wouldn't flare into flame when some neighbor boys would climb up with purloined fireworks.

That school, Linda Vista Elementary, was named for the rewards of its perch. On clear, non-smog alert days, you could see the Hollywood sign stretching across the northwest hill. The site has been reborn as a stunning public urban garden, the Stoneview Nature Center. I had no notion of the

transformation until I happened on a Facebook post from Lila Higgins, manager of the Natural History Museum's Citizen Science Program. As I scrolled through the pictures, I didn't recognize anything but the view. I asked Higgins if I could tag along with her if she was going to make a trip, even an impromptu one. I was anxious to see what had become of that seemingly nondescript corner of my old neighborhood.

We trooped out one early afternoon and I realized as I took the main road and veered off just before the park and down the narrow road toward the old school grounds that it had most likely been decades since I'd been down this narrow, dead-end street. Rolling inside the gate, in my mind's eye, I could see the campus's old configuration. I still could envision where the parking lot once stood and the perfunctory entryway that led to the main office and the "Cafetorium"—that then opened up to a set of breezeways and classrooms.

I'd brought along an old yearbook and some snapshots from that era so we could compare and contrast the change in the landscape. There's a bee hotel and a bat box and rows of gardens and the beginnings of a labyrinth where the old parking lot used to be. In the place where we used to line up before class, a cluster of chairs and flowerbeds now stand. Lila walked me through the present, and I toured her through the past. There is even a marker dedicated to the site of the old school, outlining its history on this quiet bluff. These five acres have been mightily reconsidered, and while I spotted where the old grass area once stood where some of the older girls sometimes played "Bambi," and could picture where the tetherball poles sunk into a large sea of asphalt. I almost felt the after-recess burn in my chest from bad smog days. I marveled at the transformation.

Higgins had been in an ongoing conversation with the center's superintendent, Shawna Joplin, about the gardens and upcoming programing. "I love to talk to people about how their memories connect with their sense of place." They've hosted films, walks, "nature hunts"—to track baseline

biodiversity data—and have even offered an edible-insect cooking class. The center, sponsored by the Baldwin Hills Conservancy, is modeled after the Fallen Fruit project, which encourages citizens to plant and pick edible plants, as well as to spend time out of doors in green spaces steps away from their own homes, in other words, communing in the nature that is in plain sight.

I set up time to come and take a turn through the NHM's own gardens and its Nature Lab with Lila as my guide. At the last minute, I had to postpone my meeting because of an opportunistic entry at home—a single rodent had located a new passthrough. It was the consequence of major home repair and living among typical fauna. However, in retrospect, I know I must have looked like a character in one of those old four-color Sunday-comics cartoon panels, running through my house in the half-dark, screaming, with a raised broom, swatting at air.

A week later, when we stepped briskly into the gleaming white lab, almost immediately, I got a quick glimpse of what could have been the rodent's cousin, curled up, eyes closed, under glass: My first reaction was to utter audibly, "Too soon."

But this is the glorious thing about the Nature Lab and precisely what the museum is reaching for—contextualization. I saw taxidermied specimens, graphic renderings, on video, in working, living models—all the wildlife I live around: the skunks, the raccoons, the squirrels, the coyotes, the parrots, the rat—even the stubborn ants I battle in full-swarm some summers. Connected to each, I had a story.

Lila winds me through the lab and highlights some of the displays. I am able to peek into the P-22 exhibit, an alcove honoring Los Angeles's most famous mountain lion. Biologist Miguel Ordeñana, who is a member of Lila's team of scientists, was the first to spot the mountain lion after scanning hours and hours of camera-trap footage, as part of the Griffith Park Connectivity Study that examines the interaction between city and park. The sighting, near the 101 and the John Anson Ford Amphitheater, was significant because

it revealed a remarkable story about survival. That a mountain lion who most likely originated in Topanga State Park was found many miles east—in Griffith Park proper—meant he threaded through residential areas and crossed both the 405 and the 101.

P-22 somehow wove his way to safety.

Mimicking his route, to enter the exhibit's enclave, a visitor must "cross" a projection of the 5 freeway, avoiding the onslaught of the swift flow of traffic, which allows the viewer a sobering sense of how difficult it would be for our fast-moving cougar to cross it—for food or to mate or to simply explore. My trek was far from successful; I was "hit" three times in my attempt—road kill, several times over. The sheer scope of information on display about pumas, the terrain, and even a soundscape was compelling and instructive. And even though, as an adult, I am not necessarily the target audience, only halfway in, I was making plans for when I could come back and move much more slowly through.

———— ✦ ————

In certain ways, when I was a child, this museum taught me awe. A very specific shading of awe: What it was to be big and small—at once. I grew up standing in its inky dark, sinking into those wondrous dioramas of nature scenes across the epochs and from around the globe. They were rectangles as wide and wondrous as movie screens, they seemed. I spent school field trips getting a neck ache gazing up at what seem to be the impossibility of the dinosaurs, the mazes of their superstructure. I took a summer ornithology class in which with tracing and sketch paper and colored pencils, I learned how to render approximations of birds familiar to our environs. We pasted and cataloged feathers, and we learned the difference between down and eiderdown—but still it was at arm's length compared to the displays I interact with today—the personal narratives, the site-specific fauna, in-real-time infrared images of what a snake might see as it moves through Griffith Park.

But I kept those sketches and the workbook with its illustrated pages and sleeves and my many careful notes well into my adulthood; a memento of time and place.

We stroll through the new gardens, which sit on what used to be an open, asphalt parking lot—153,000 square feet of concrete and hardscape—crushed, repurposed. The entirety renewed, fashioned into a buzzing nature park—wild, pollinated gardens, bat detectors and bee hotels, a placid pond to gaze into. The pathways are lined with native plants identified by signage placed at varying heights so adults and children can all interact. I recognize the trees and shrubs and wildflowers that I see as I climb the trails of both Griffith Park and the Angeles National Forest. There is something grounding and magical about this place. There is a pond over which dragonflies soar; an edible garden where we pick figs, sweet ripe cherry tomatoes, hot peppers. It's an oasis. It's a reminder to me that we are always trying to find a pause, serenity. It's just three-and-a-half acres with a view—neck craned just so—of downtown Los Angeles. But it is its own enchanted kingdom.

I have scores of questions for Lila—about the garden, about L.A.'s biodiversity, about her adjacent work along the L.A. River, but the thing that leaps out first is this: "When did you first feel comfortable reaching out and catching bugs in your bare hands?"

As long as she can remember.

Higgins grew up in a farm near Worcester in the British Midland, both of her parents comfortable with the outdoors and with farming in their blood. Creeks and rivers and woods and dirt paths were all a part of her childhood, so a move to Los Angeles (to live amid its storied freeways) years ago, seemed, well, unexpected. "I remember people saying to my parents essentially: "How can you allow your lovely English Rose to go *there*?"

I trail after her along a path and she stops to peer up and whisper, in the highest branches of a silk floss tree, two mourning doves nest. We cross to the pond, and off to a corner, there is a semi-hidden thatch with rocks and

branches. The grounds offer all sorts of nooks and pass-throughs for children to explore. "All that loose-part play," she points to the river rocks that have been arranged into towers or in spirals. "Loose part is a thing in a play work: where a stick can become a sword, a magic wand a pointer, and rocks can become a car."

Also at play are the gardens, which are, as Higgins notes, "buzzing."

⎯⎯✦⎯⎯

"Los Angeles is a biodiversity hotspot," she explains. That designation is given to a location where there is not just a large range of plant and animal life (there are over 1500 species of domestic, vascular plants that are indigenous to the region), but also those species are under threat. "Over seventy-five percent of the natural vegetation has been lost here—which is why it's called a 'hotspot.' So we do a lot of companion planting—so aside from the edibles, we are putting in plants that will attract beneficial insects, pollinators, or others that will attract ladybugs that will eat aphids."

One of the urban myths that Higgins's work handily dispels is that you need to pop into a car or book travel to the outer edges of the city to get deep into Los Angeles's nature. Within this lush oasis in the center of bustle and noise and concrete, the contemporary city seems to disappear; you have a sense of what was. Every day, she steps out of her door of her Koreatown home and encounters snails and crickets or slime mold—the small but startling wonders we live around. "People think I'm an expert," says Higgins, "but like them, I'm learning all the time."

I have been tested by the elements—nature's wiles—and my own slow-learning curve of late. I wake early on the Friday before Labor Day weekend, ready to finish packing and head up the coast for a short trip into Northern California's redwoods. It's nighttime dark when I put the kettle on for coffee

and as the sun begins to rise, I look out the front window and note a still form on the grass of my parkway. I slip on my shoes and venture a bit closer. A baby opossum. I creep in even closer to check to see if he or she might be sleeping, its body curled so tightly. But a few steps in reveals otherwise. This isn't a game. I phone the Humane Society, surprised to get an answer so quickly, so early on a holiday weekend. "Someone's already called." she says brightly, as I recite the first few numbers of my street address into the receiver. In minutes, it seems, a man arrives in an official-looking uniform and black shades. He carefully inspects the corpse, and then scoops the tiny body up into a shiny black bag. I have to wonder what the opossum had encountered.

I put this question a few weeks later to Beth Pratt-Bergstrom who works with the National Wildlife Federation, and is the regional executive director for the California Regional Center.

A multi-year drought and the resulting effects to our terrain—both those apparent to the eye and those more imperceptible—have made Angelenos more mindful of how we interact with the space we share. So much more aware of wildlife slipping into spaces that they had once seemed to circumvent. But it's been more than drought and the attendant altered behaviors that have broadened both discussion and action around urban wildlife: That pitiful photo of P-22, right after he'd encountered rat poison in 2014, a haunting feature of evening news and social media, keeps cycling through my brain.

What's changed in L.A. that she's observed? "There's been a real value system shift. Some of it has started with taking pride in these backyard mountain lions," she says. "P-22? He's like Brad Pitt."

She's only half jesting. Pratt-Bergstrom's 2014 book, *Mountain Lions Are Neighbors: People and Wildlife Working it Out*, is an exploration and consideration of California's changing terrain partnered with illuminating, practical advice on how better to coexist with our wildlife. Researching the book brought her into Los Angeles far more frequently than she had been in the past. It pushed her past her own assumptions about the Southland. "Yeah,

yeah. I had that Northern California thing," she admits. But she wasn't just taken by the vibrant wildlife and the curiosity around nature in general. The way in which P-22 was being studied, tracked, and written about in the press told her something else about the region that people outside of Southern California might not know: "In a certain way this idea of wildlife as celebrity is something that the stuffy Washington types are horrified about. *But* people here do not think about P-22 as a pet. Absolutely not."

In Pratt-Bergstrom's experience, the P-22 saga has become an unexpected teaching moment—one that just happens to have an attractive and mysterious protagonist and a dramatic story arc about survival. Trailing P-22's movements, Angelenos are learning about not just the cougars roaming their backyards, but about the environment and what sustainability and connectivity mean. "They are valuing wildlife." Case in point: "When P-22 ate the koala at the Los Angeles Zoo in 2012, in an earlier time he would have been gone, put down. People would have been afraid. But the zoo wrote a note *apologizing*. That was a real shift in the way we've thought about cougars and how they move through our spaces."

The era of diorama wildlife is behind us. As Pratt-Bergstrom explains, "Wildlife is in your face here. In the most unexpected places. So the goal is to try to understand that yes, mountain lions are scary, but perhaps most important is to get folks to interact daily with wildlife so that they can understand how to safely interact with what they encounter."

The key is not to respond in fear, but with respect.

<div align="center">✦</div>

Pratt-Bergstrom has been part of a high-profile campaign to build a connector across the 101, allowing mountain lions like P-22 to more easily move across the region to mate and to find food—without risking their lives.

It doesn't stop here.

Just before we sat down for lunch in Highland Park, she and her Southern

California assistant, Tessa Charnofsky had just met with fifty third graders from Esperanza Elementary and Union Street Elementary at Debs Park just minutes away. "The kids are why we do this," she explains. For talks like this, she might take her P-22 cutout for selfie photo-ops, maybe later show off the P-22 tattoo on her arm.

"The class will be building a wildlife crossing and they are doing a whole unit on mountain lions," she explains. "They write songs about P-22. Draw pictures. Ask questions and tell stories. They have a better understanding of what they they live around and of how they can contribute to the livelihood of that," she says. "What we want to impress upon folks is that you can do this—in your own yards—make an urban wildlife environment. In six months, they are already increasing biodiversity, helping with the drought and carbon sequestration."

Kids, Charnofsky tells me, "seem to get this idea of connectedness right off. They understand that if each of the schools put in a garden, they don't need a continuous corridor, but enough encourage the wildlife."

This study is a way to explore overall connectivity, and it's an L.A. project, says Pratt-Bergstrom, that started with an L.A. cougar. "We aren't stopping at connecting the 101. The plan is to reach across the region," Pratt-Bergstrom says. "P-22 shouldn't live in isolation."

It's a big circle; the project, she reflects, is the ultimate sort of collaboration. "Just last night, I was sitting on the balcony of my hotel downtown and looking at the lights and the moon. And I'm thinking about *Blade Runner*. And there is a layer of celebrity and entertainment and Dystopian L.A. Then I'm thinking about the yuppies down there at Whole Foods sipping their wine, and then I'm thinking about the mastodons and the cats that were here. And that comes all the way back to P-22. Here you have this cat who is the symbol of the Ice Age living with a symbol of *our* time—the Hollywood sign. And to take it a step further, the reason he is able to live in Griffith Park is because of the deer herd that is sustained by the lawn of Forest Lawn Cemetery, and

that is where all the dead celebrities are buried. So *he is* able to live because the deer are sustained by dead celebrities. It's the ultimate mash up."

Because Southern California foothills run close to the sea, coastal sagebrush commences soon after the giving out of beach plants. Sagebrush grows below three thousand feet, mixing at its farther reaches with lower chaparral. From one-to-four-thousand feet, Coastal California is chaparral country.

—Kevin Starr, from Inventing the Dream

I keep turning Pratt-Bergstrom's time/space continuum fantasia over in my head, as I take a second walk within the new green-edged pathways along the Exposition Boulevard entrance to NHM. Summer Nights in the Gardens is a series of after-hours events the museum hosts to introduce Angelenos and visitors to the buckwheat, oaks, and sagebrush that are under their noses—all as close as the Expo Line. Tonight there are DJs and craft cocktails, created from ingredients picked from the grounds' Edible Garden. Higgins and Miguel Ordeñana, ringed by a cluster of children, tend to a large red weather balloon that will float above us to record an aerial map of the grounds.

As the sky darkens, I sit on a carved-out log and watch twin brothers—who remind me of my own brother—at play in dirty dinosaur t-shirts, their long day almost done, just as the Expo Line pauses intermittently to let an older set of revelers play in the park, among the buckwheat, oaks, and sagebrush.

A far-off feeling of old Los Angeles catches me off guard. It's a sensation that I don't experience as much anymore, one that I didn't know if I could even locate. And I think that's why it hit like a thud, the way that the anvil would land on Wile E. Coyote in those old Warner Bros. cartoons—nothing

like the coy coyotes who slink through the streets, or the ones who peek down at me from a trail switchback.

I don't know if it was just the ease of sitting in a comfortable silence with an old friend, the calm of a late-summer night, the diversity—in age, ethnicity, ability—of the people flowing back and forth under a light-show sunset sky. Re-encountering an old self is like turning onto a hidden path. Not one on a map, but one of memory: I can smell the sage, there are pebbles worked deep into my shoe, I am in wonder of the rustic aura that is both city and the wild it was carved from, yet still part of. What drifts in, crystallizes for a moment, is a lesson I knew so long ago but had forgotten: We are all beings hoping to cross, not to be isolated, wanting to sample and be nourished by each other, by our habitat, and our surroundings.

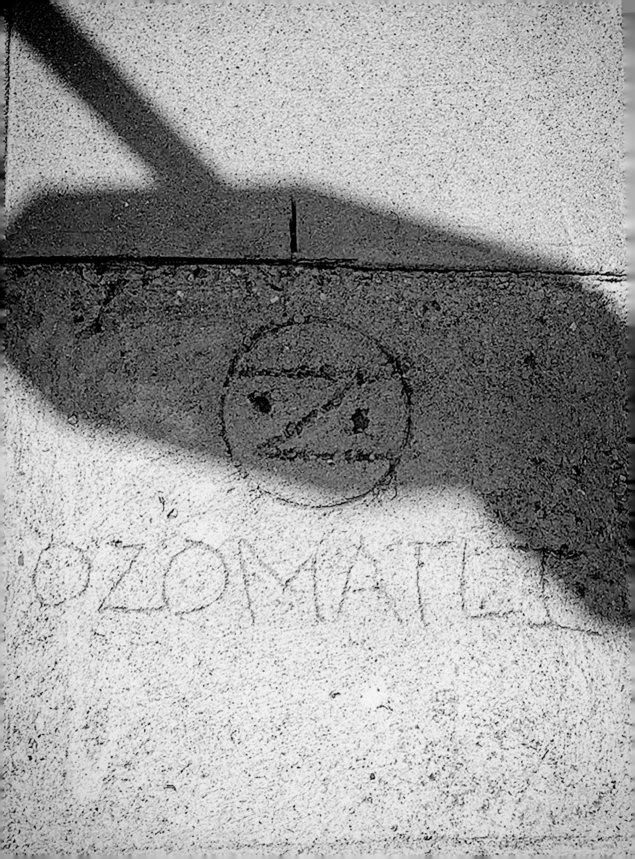

10 *Flow*

flow [n. A rapper's ability to rhyme to phat beats in a skillful manner]

. . . my earliest memories bodysurf the warm comforting timeless-ness of Santa Ana winds, whipping me in and around the palm-tree-lined streets of Santa Monica. Me and white boys Steven Pierce, Ryan Foggerty, and David Schoenfeld sharing secrets and bubble gum. Our friendship was a buoyant one based on proximity, easy-to-remember phone numbers . . .

—Paul Beatty, from White Boy Shuffle

GAMEFACE

The mirror wasn't magic, but what could happen in it was. Most mornings, through junior into senior high school, I bore witness to it. My friend Corrine would cut a beeline to the girls' room, before anyone else might catch sight of her. I'd fall into step and follow her inside. There, she'd meticulously recast herself within what was left of fractured, murky looking glass.

Yanking open her denim bag with quick fingers, she fished for fire: Purse-worn matchbooks or Bic lighter—discards you could always scoop

up somewhere. The Bics, sometimes cracked, three-quarters empty, were sometimes left in haste, stashed in some hiding space perhaps near the portable classrooms or dropped along the western edges of campus near the athletic fields, lost or stowed for safekeeping, damp with dew. We always passed by there first on the way in, eyes scanning.

The fire wasn't for anything illicit, not on the books at least. But it was necessary, for this was a quick and covert act of declaration, a rushed rite-of-passage crammed in just a hair before first bell. Looking back, in a certain sense, she was indeed going somewhere.

First, the stub of eye-pencil held over the flame. Then, shaken out, cooled with a quick huff of breath. She moved in close: The very thickness and angle precise; just the right sort of play, of malleability, the flame allowed her to achieve the lines, the smudge, the blending that left her an open question.

Never far from reach, that red pencil was a wreck. She guarded it, *and* the fat tube of mascara that she'd wield next with the care and earnestness of portraiture.

I kept watch on the clock. My eyes urged *hurry* into the mirror's reflection.

<p style="text-align:center">✦</p>

We were always sensitive to images, the ones we cast, the ones we absorbed around us. Teenage girls are; we vibrated with it. We were always reaching for something just out of grasp, or threatening to slip away.

I was awed by the sleight-of-hand, the red pencil jabbing, smoothing, jabbing. What did she see afterwards? What was in the self-making? I don't know. We never spoke of it. This ritual wasn't simply about beauty in that sense of teen magazines or the whiff of Hollywood that we lived at the edges of (our campus situated mere blocks from Metro-Goldwyn-Mayer studios), but it certainly was about being seen; it was about belonging.

Her real name is not Corrine, but I am writing her in, into a being, into a spot on the landscape, as she did many mornings. That girls' bathroom was

rank with weed and pee and the lingering stench of wet tobacco butts, drifting in the basins and bowls. The thought of it, decades gone, still smarts my eyes and nose. This was the place the hard girls would beat your ass straight up. Someone had wrenched off most of the stall doors so our privacy was mediated, but it was her laboratory. And with a few fast lines, she drew herself into a clique of girls from other countries and tongues. She wasn't trying to look *like* them; it was a way to set herself apart. It wasn't an act of survival, but it was akin.

I had no such skills. No game. But my orbit and circumstances were very different from hers. I imagine that as an Irish-Catholic girl watching the landscape and populace change around her, she saw herself moving closer to something, not necessarily walking away. Friendship and, of course, testing boundaries led her. But there was something else. Before we used words like ally or accomplice, she found a way to stand shoulder to shoulder in the ways that mattered most—being quiet, listening, defending, reaching out. She spoke a passable schoolyard Spanish, well enough to be understood, and perhaps most critically, to understand. What was most important to me was she had your back. She was part of an emerging new crop: those who were bold enough not to run from, but to step out and embrace what was new; what we would be in conversation with each day. Be *curious*.

For me, like many of the other African American students who had just settled into this new place, I suppose I was looking to find some semblance of what I'd left, just minutes away—tight-knit extensions of our home and family. Mirror comforts. As a native Angeleno, I spent my earliest years in neighborhoods peopled mostly by black families who were part of different waves of the Great Migration, so some days L.A. could feel very Southern, leisurely, and golden—that would be expressed by what was grown in your garden, or where you went to church, or what you ate for Sunday dinner, or your dialect/regionalism (Did you call it "supper" or "dinner"?) Perhaps it might be evidenced by how news of home filtered through—by phone or mail? Or

who showed up on your porch to bring it, accompanied by a casserole pan covered in dish linen. These would be some of the details and rituals that over months and years, I would learn to share with my new friends in these new environs over time.

I've long thought (and written) about these intersections of old and new—these liminal spaces, "border towns" here in Los Angeles. They could be full neighborhoods or just nooks that were the result of redlining or white flight or the abrupt transitions—the afterthoughts—that reconstituted a street or entire block. These were in-between spaces where new identities formed. Who was left to be together to work around or through our preconceptions; or our anger? To break it down. And what did that mean? In the 1970s, Los Angeles wasn't just a destination for dream-chasing talent: In those early years, I more often came into contact with people whose parents had fled war- or disaster-torn countries; others who sought political asylum, and still others who had spent decades saving change in glass jars and bottles, trying to book passage to close the circle on their long-estranged families. I grew up around a lot of outsized dreaming—as expansive as it was frantic. Somehow we all ended up swimming in it—thick and deep desire—and mixing it up. Together.

Who would we grow up to be if we carried the benefit of proximity—of all the stories we intersected with the new stories we created together—into adulthood. Would we look for places and moments like this forever?

There was always that one kid—or three—who wandered away from the pack, who just said "fuck it." who just bucked everything—the kids who found the narrow parameters of what it meant to be XYZ [fill in the blank], incommodious. They were curious, but more crucial, they were tuned to some sort of frequency. They ran after something that might be off-limits or something that was tantalizing or dangerous because it was simply unexpected, or it lit up something, some unexpected place, inside.

On our campus could have been:

The black kid who surfed	Good enough to be featured in a documentary
The white kid who pop-locked	Good enough to be on *Soul Train*
The Japanese American kid who played basketball with a J.J. Walker comic back-bend and finger-splayed "swish"	Good enough to attract scouts
The Chicano surf punks who played guitar Crip-walked.	Good enough to land a contract

Good enough to just be—in the moment—in the flow.

We had a big stage—Los Angeles—so, if you "showed out," shined just the right way, you could reach beyond imagination—beyond, it seemed—the outer limits.

You'd look up and there'd they be: a tiny hologram of themselves on the rumpus room's black-and-white TV: "Isn't that Kerry from X-Period? What's that fool doing up in there?"

But it was all awe. Not judgment.

We had proximity to the "big league," influencers. This was not amateur hour; it made us all both bold and blasé, but also oddly terrified—make-or-break choices it seemed: You *could* up the ante. No, you *should*.

Who we would become was informed by a deep understanding of place and who inhabited it—and of secrets revealed in the intimacy of a long drive pointed nowhere in particular, finger pressing "rewind" on the cassette deck, within the whispered confidences of a sleepover, or on a bike ride pushing past old boundaries: It was the fruit of newly forming alliances in this new

place of possibility. How much stronger could we be together? What sort of future island—refuge—could we collectively build?

This was not just some sort of "passing" game no "silly wigger shit," my friend Byron would say many years later. "You really had to prove you were down. That meant you had to be *real*. And bring it." You didn't get a pass. You'd catch hell if you were trying to ingratiate your way in with some lame theatrics. "You had to walk through fire." Before we used the terms squad, or even posse, identity was about who you "ran with"—it was a way of looking through a different lens.

We were just waiting—no, *aching*—to be grown in Los Angeles, to have access to everything around us. That wasn't simply about what we looked like, it was who we might be, inside and out.

RECOGNIZE

What was the gift of Los Angeles's mix if you gave yourself over to it? If you let it mark you? What was its gift to the world?

I've always found it difficult to put it into words. It's sunk down deep in a feeling. Instead, I often grasp for an approximation, perhaps a metaphor.

Sometimes, it's like a soundtrack: a ragged guitar solo cutting through sleek appointed calm, a slinky piano fill, it's a tweaked and bent hip-hop sample, flat and sly as a toy piano; it's the Doppler effect of an ice cream truck slurring its way down a long block. Other times, it's scents: garlic and flash-fried fish; gardenias and star jasmine. Or the season when you can't discern if its brush fire or *asado* or chimney smoke? Or it's our singular intervals, a way of telling time: Scrounging up car-ashtray change, hot to the touch, for August scoops of Thrifty Drug Store ice cream, it's a Saturday night fleet of low-and-slow sedans, bass-line thudding, it's fire season's fury. . .and its pink skies. It's summer not ever giving in, really. Or simply taking in the "sparkle dust" of city lights as you ride the dip out of Baldwin Hills, heading north on

La Brea just after gloaming:

> *Can I get a witness?*
> *Can I put it in a bottle?*

This was the text/experience that ran parallel to what was the working narrative of native L.A—Hollywood and beaches, cool indoor/outdoor tropical expanses, the endless cocktail parties.

You didn't see us in books or films until later, much later, when we could finally write ourselves into the center of the page.

So much falls off into the edges: the bus riders, the walkers, the running-on-fumes, fenderless beater on blocks in the yard, the fish drying on the clothesline, front yard altars—the sort of patched-together life of old-home and new-opportunities, the clashes and the coming-togethers.

We, as residents, as natives, have been left to navigate through an obsession with the superficial, one that borders on arrogant. Much of it we ignore, shrug off. It's almost willful mythmaking: "I mean there's even this myth of suburbia, that the suburbs are all white," Dana Johnson tells me. Johnson's novels and short stories move close into those obscured spaces. Those off-ramps we whizz by on the 60 or the 710 or the 118 are addresses of Southern California lives, too. So many of the assessments about our region, often by querulous outsiders have been myopic if not simply lazy. "After we moved to West Covina from South Central L.A. was when I met and was friends with people of so many different backgrounds—Mexican, Korean, Jewish—but you wouldn't know it from the way people casually talk about it. About, L.A. And I'm still surprised. And it just happened the other day at a reading I did in San Francisco—when people still say: 'Wow! There's nothing there.' But that can only be people who don't know a *thing* about Los Angeles. Only they can say shit like that now."

One was wise to the omissions early. What you walked through daily did not square: I drank in books and movies about L.A. I was curious, even at an early age, about how we came to be? How this working organizing thesis came about? How were we seen? To the outside world we were Star Homes maps. We were noir. We were crime stats; we were "right on red." We were Beverly Hills lunch and mineral water; we were the airport; we were beach and mountain; we were blond. We were bored housewives; molls. We worried about merging. We were long stretches of nondescript gray road; we were not walkers; we were not cosmopolitan, we were parochial, *and* we were not a real city.

But where was the city I knew? Not in these pages or in these film frames. And so where did all of my friends fit? Where was the Los Angeles south of the 10, East of the 405, the Los Angeles of accents, of concrete rivers, of bus stops, of house parties, of funky roller rinks, of flourishes of vivid self-presentation, of store-front churches and work-for-hire, of community uplift, and organizing?

My loose tribe wasn't chasing an L.A. dream per se. But we definitely reaped the benefits of occupying a space where it was not just encouraged—but expected—to take chances and risks, emboldened by the mental space to try it all on, to pump it up, to power forward.

. . .oh luz, i had so many things to say. . .
all i do is remember, think of us/our people as we were
or could have been—apart, the awful silence
together, the awesome storm—

—Wanda Coleman from "luz"

LET'S CHOP IT UP

Proximity sometimes has to be nurtured—if not nudged, "Well, *guided*," Lori Nelson tells me. We are huddled over a late breakfast, going over early history. I've known Nelson for decades now. She is an expert at the delicate skill of bridge building, and I'm curious about the long-term effects of L.A.'s particular model of coexistence—the urban sprawl that allowed for, in moments, pockets of diverse communities. As the founder of Encompass, a Southern California-based youth program dedicated to encouraging compassion and appreciation of differences among teens, she's long worked to steer youth into more candid and mindful dialogue. What she's learned in the years of interacting across race, class, and gender lines in Southern California is that you might live side by side, but you may not know how to close the last bit of distance.

Nelson, and her work, first came to my attention back in the mid-1990s, during a spike in L.A.'s "melting pot at a boil" turmoil—post-riots, post-earthquake, post-O.J. Simpson's slow-speed freeway car chase—when I spent a weekend up among the tall trees of Idyllwild with 150 L.A. high schoolers, at Brotherhood/Sisterhood Camp. Back then, when L.A. seemed to be the poster child for all that could go wrong in a city, she was youth coordinator for the National Conference for Christians and Jews (NCCJ), who sponsored the summer retreat (two, one-week sessions in June and August) and its guided series of workshops and discussions—about race, ethnicity, religion, and gender. For many Los Angeles youths, those sessions set them on a path toward seeking deeper engagement with their communities. And, as a byproduct, in some cases, the interaction forged lifelong friendships. Campers have gone on to be novelists, community organizers, academics, psychologists, poets, journalists, mothers, uncles, and grandfathers who are in conversation with the next generation of Angelenos.

For nearly five decades, the organization ferried busloads of Los Angeles teenagers up into the wilderness to discuss head on what makes them both

different and alike, and to help them identify their personal blind spots of prejudice and identify bigotry's landmines in their day-to-day lives.

Stewart Cole, then director of youth and education for NCCJ in the L.A. region, developed the program-model in the 1950s. He'd hoped that by exposing students to the diversity they lived around, that familiarity would create bonds and smooth tensions. Compassion through interaction might help create new and durable alliances.

Since its inception, first as Brotherhood U.S.A., students traveled from neighborhoods across Los Angeles. Many came thinking they harbored no hang ups, no ill will, no unexplored prejudices, only to find that they stumbled when they realized they were equipped with only assumptions and generalizations about other races or felt distanced from parts of their own identity that had been hidden or were yet to be explored. That summer camp session in the mid-'90s was one of the first places I witnessed a comprehensive and rigorous facilitated discussion about power and privilege among diverse youth in the context of L.A. The facilitators made space and stood at the ready for the fall out—be it tears or fury or catharsis. At the end, the hope was that the awareness and new knowledge helped close the distance that much more.

Being outside of familiar environs—the influence and the distractions—helped focus the students, as Nelson told me for my *L.A. Times* story: "You can't talk about this stuff down here, in the city. I mean, people get hurt in lots of ways. We give them a safe place. The tools and incentive. They have to see that something is going to come out of this, because this is risky."

It *was* risky and rough edged, because even though we all lived adjacent lives, it didn't mean we knew how to manage them.

In comparison, back in the dark ages, the late '60s and early '70s, post-Watts Riots (later re-characterized "Rebellion"), I grew up with elementary school units that celebrated culture through "food" and "fiestas." I wince at the memory. There was always the shame-producing moment when one child didn't have a show-and-tell totem that encapsulated her "culture's" story, which left teacher and pupils awkwardly stymied. It made an exercise of celebration, an inelegant, forced stretch toward inclusion.

The gloss, back then, about L.A. coexistence often tended toward a sort of *kumbaya* template, but you didn't have to look too far beneath the surface to see the truth of it all. That melting pot trope was often a distraction, a tool that tended to barely obscure compartmentalized, and consequently unresolved, bigotry and across-ethnic-lines tension that had existed here for decades. Even mid-riot turmoil, Rodney G. King attempted to address the larger wound, the depth of the trauma: "Can we all get along?"

But no one seemed to know where to start. "We had to really push through a lot of layers to get there. . . just to the table." says Nelson.

Within certain breezy narratives about the city, on the surface, Los Angeles had come to represent "laid back" and "easy coexistence" to the rest of the world. That was due in part to the reality that segregation here was not de jure explicit. But its evidence and consequential wounds were sometimes just as deep as the causes were hidden. This is why neighborhoods of color blew up in fury in a series of historic conflagrations in 1965 (Watts), 1970 (Chicano Moratorium), 1992 (post-LAPD-officer acquittals for the beating of Rodney G. King); these are scars we still live with today: "When things blow up time and again, the only ones surprised were the people who weren't paying attention, or didn't need to," says Nelson, "people outside of the sphere."

For Angelenos to take steps toward coalition building across race/class/

gender lines meant blasting through the empty bromides, the superficial optics of coexistence. I'm reminded of a moment at a conference a few years back, when another reporter shared his "nagging epiphany" about the 2004 film *Crash*. The film, through multi-points-of view, struggled to take on L.A. as powder keg. Tensions around race, class, gender: "It just seemed so dated," he quipped, his voice as crisp as a blade. "So 1992. With all that race stuff." As if that messiness was over and done with. All that tipping-point anger. Perhaps for him, it was.

We weren't then—and we aren't now—looking at any of this in a rearview: The scar of redlining can still be mapped by examining the neighborhoods that are now targets of gentrification's reach—those urban tracts to which communities of color in earlier decades had been relegated.

The grievances and disparity of L.A.'s communities of color were front and center after 1992's urban unrest, and now gentrification has become L.A.'s twenty-first century flashpoint—fomenting protest and sparking united push-back.

As Los Angeles's housing crisis surges—with homelessness up twenty percent, a record high—the city has become a developer's high-stakes chess game. Luxury housing aimed at high-income renters and buyers has already sped up gentrification in and around the downtown Los Angeles Arts District, Highland Park, Echo Park, and Boyle Heights. Within the ever-widening target are those communities south of the 10 freeway and east of downtown—the remnants of the houses, yards, and gardens and scale that defined a very particular middle- and working-class Los Angeles. It rewrites a neighborhood's long-standing story, its backdrop, and its critical players.

Displacement and erasure rise to the very top of conversations about threatened neighborhoods of color: It's the sort of continuation of soul searching that Nelson sees in her day-to-day dealings—classroom discussions where she talks with students about bias and blind spots or potential hotspots at Los Angeles County High School for the Arts, where she teaches

a course titled "Acting for Social Change." It's also that tinder that writer Johnson experiments with in her stories and books—at how contested place is often about contested bodies.

What's also at stake now, says Johnson, is losing the naturally evolved pockets in the city, the places where diversity was the happenstance of decades of demographic shifts: "I feel like the more interesting spots are being gobbled up. You're seeing this homogenization. This 'whitening.' that has come with gentrification."

Gentrification doesn't just remake the physical look of a neighborhood, but it elides a very critical aspect of L.A.'s unique multiethnic history—these pockets of experimentation.

These hard won spaces "with old L.A. character," where a delicate coexistence was built over time, clashes, and ultimately, goodwill, are slipping away. But, says Johnson, they are not giving up without a fight. People are saying "hell-to-the-no."

Our house smelled like kimchi and soybean paste, not potpourri and potatoes. —Chef Roy Choi, from *L.A. Son*

FLAVOR

Sometimes, when people ask where I'm from and when I respond *Los Angeles*, I can see something pass through their eyes, an on-the-fly calculation at work.

Really? You don't seem like it.

It's always meant as a compliment. But it's one that irks, hangs in the air.

I spent years trying to sort out the proper retort, only to conclude that it doesn't deserve one.

Ever since I can remember, the response always varies or modifies, and it is a manner of assessing the way in which L.A. exists—and changes—in the

collective imagination. If Los Angeles itself is ever evolving, being an Angeleno must be something that by consequence is too not-fixed, that it is an identity in flux.

What far more interests me is how Los Angeles exists in *our* own imagination—influenced by that perception—how a sense of place affects and shapes *us*: TV beams in weekly, scripted scenarios, movies seduce, but so many of us who grew up around narrow narratives of place work against or away from that; we're not all chasing the round-the-next-bend dream (film industry, real estate, peace of mind), but often we are the fruit of those who came in search of it.

For us then, the kids who lived in those off-the-radar places on the map—a dead-end street, "below-the-10," or over the bridge—finding your path, your way, meant finding your terrain, your tribe, and your heart.

For years as a journalist, I've written pieces—news stories, essays, profiles—that push against exaggerations or misapprehensions about Los Angeles—the outdated assumptions that still pass for truths. In so doing, I've tried to focus on a particular "place"—a location that you can't find on any map, but one many Angelenos move through daily—this nexus of identity and sense of place. How do we carry a changing Los Angeles around within us? How has Los Angeles marked us?

We all memorize our way through the city, each generation, each iteration. We define our personal Los Angeleses through landmarks, hideouts, pauses, and conceived-out-of-necessity identities.

We move through a collection of roads that spin us toward some next chapter of understanding. In certain ways, it's ongoing coalition building: Whom we connect with gifts us another small brick of clarity and compassion—a sense of deeper self-making. And with all this connecting, mixing, and borrowing, if we are lucky, it can produce something as uncanny as it is indelible.

REPRESENT

At this spur on Glendale Boulevard where Echo Park gives out onto Westlake, Wil Abers rotates his steering wheel just a slight quarter turn, angling us away us from 2nd Street to Lucas. We're idling at an intersection that, once the green light flashes, offers four different possibilities. I always wonder how it is that more people don't collide here.

"You know what this was? I mean before." Wil asks, tugging a thumb toward a condo complex on the southeast corner of the intersection.

I know the shorthand: I know what he's really asking me: He's gauging just how far back and how deep he needs to reach back into the story. It's something longtime Angelenos do. Which iteration do *you* remember? Like him, I remember this corner, not as it is now, but as it was.

Like I do, Wil, moves through his *once was* and *used to be*'s with a sense of free-floating longing. I remember the relic that was once there, the Belmont Tunnel also known as the Toluca Street Substation, remnants of the old Pacific Electric Railway—what was left of it. You knew it from the forest of wild-style graffiti and the clashing echoes of voices and boomboxes and bikes being kicked off of so quickly they popped—with a zealous bounce—off the ground, wheels still spinning. I sometimes think they'll still be there—mostly boys and young men: white, black, brown, Asian—throwing up pieces, declarations, in chartreuse, cobalt, fire-red. I could see it from a distance just as I slipped out of the last curve. And sometimes too, the silhouettes at work—they themselves seemed in a certain way, a living mural of the moment. But now, idling at the light, that scene is scrubbed clean, gone—that condo complex is still there, mute and inscrutable—revealing nothing of its various pasts from the street. But we knew better.

Those ruins had evolved into the natural look of the landscape; tumbledown and taken over; now razed and neatened: it looks as if it hadn't or could have never transpired.

In this brief exchange, just this acknowledgment, we've created a bubble

of empathy.

Wil is known by his concentric circles of friends, family, and following, as Wil-Dog ("or just Dog" as he tells the barista where we'd earlier grabbed two cups of coffee). He's the bass player and co-founder of the band Ozomatli, an ensemble in many respects that could only have grown out of L.A.'s hardscape—a frenetic, wildstyle mix of salsa, hip-hop, punk jazz/funk—roots music with energy and an urban swagger. On this summer afternoon, we've embarked on a short pilgrimage back into the center of some of his origin stories. As he drives deeper into Westlake, he points out more spots—street corners, building façades, not-long-to-be vacant lots—that require us to picture what used to be. Down this street, he gestures with his chin, "is where Ozo came together. It was by happenstance and for a cause," he recalls. "A friend of mine was raising money for the Peace and Justice Center in L.A. I was working with the California Conservation Corps at the time, and my friend asked if I could put a band together. We could charge five dollars at the door and we'd have people doing silk screening and there'd be food and we'd be playing our instruments. The proceeds would go to help the youth in this area."

That alliance for a cause—across race, territory, and class lines for a night—would produce some sort of alchemy that stuck. But he didn't know right off.

But he'd been in training for this sort of of-the-moment hybrid mashup for as long as he could remember.

Born in Long Beach, Wil was nine years old when his parents split. He landed with his mother, who had to hatch a quick plan: "She bought a bus for like four hundred bucks, and it was converted," he explains. "We were homeless." She and Wil traveled the east-west length of Venice Boulevard, "basically from Skid Row all the way to the ocean." They pulled over and camped at intervals until parking laws required that they move along. He ended up learning the city through this artery of road that rolled through distinctive

L.A. neighborhoods. "You know where Rose Avenue hits the ocean? Venice? The parking lot? That was our main space, when we could stay there. So like for two years, when I was like eleven to thirteen. We lived there."

Wil's most important tether to the rest of world was school: The 32nd Street School Arts Magnet, which pulled together a mini-Los Angeles within the campus footprint. "That was the greatest thing I had." With his nomadic life, "at least, my friends could stay the same." Because it was a magnet school, the ethnic balance was stipulated. "So I would say there was about forty percent African American and forty percent Latino and twenty percent the rest. Those aren't real numbers," he stresses. "But it's what I remember. It was mostly people of color and then some like more-leftist type of white kids, for the most part." The most advantageous benefit: "It just put me in the face of so many people from *all over* L.A.—Bell, Park La Brea, Boyle Heights, Cypress Park."

Like most schools, cliques and circles formed around similarities—whether it was ethnicity, or location or interest, but *because* of the mix, something else was also attainable: proximity to difference, and to new worlds. "I had a best friend when I was there. Andy Hernandez. He grew up in Eagle Rock. He had a Mexican/Native American father who wasn't around, and a white mom, and when I was ten we became super close," he remembers. "We were like the 'cool white kids,' I guess, of our school. And when I say 'cool' I mean we could assimilate. My whole life has been assimilation. It's been about not trying to be white. Like seriously. I was really good at it, though. I became a pro." For him, it was a chance to break free and float within the new territories he'd encountered and the friendships that grew out of trust.

His new maps drew in new neighborhoods, off his Venice nexus—it included friends created from school connections and loose affiliations beyond—when he'd travel with his mother talking to women about politics and the power of organizing in housing projects across the city: from Nickerson Gardens and Jordan Downs in South Los Angeles to Estrada Courts in Boyle

Heights. "She would go in to talk to the women there, and I would go outside and play. And this was what it was: fitting into *their* worlds. I got really good at doing it. I never really thought about it until I got older. It was just what I did." He picked up Spanish, slang, but more, there was the groundwork for an evolving worldview.

Later, when his mother remarried and moved to the Bay Area, while he was in high school, Wil was winging it: "I was couch surfing so I learned the ins and outs and rules of other places—often the hard way," he admits. Friends became family in moments of need. These friendships were passageways and prisms. They allowed him to access and view Los Angeles from varying points-of-view. There was no one sentence that could sum up an "Angeleno experience." It was vivid, peculiar, and often chaotic. There was room to take risks, flounder, and perhaps, most important, to improvise.

<p align="center">✳</p>

At first it all seems random. Scattershot: The casual intersecting, the new collection of friends you glance into. The trouble you court. The alliances you make. The pace. Scenes come together, broaden, merge or transfigure. And in the moment, you're too close to it to really know, to really measure the effect of the influences—of people and place and your changing sense of self.

Like those crews jumping fences at the yard at Belmont, Wil had his circuit, his haunts, downtown L.A. near 9th and Figueroa and all that flat-scape of once-open-air lots; or a few miles west near Dorsey High School, "Sometimes we'd jump through a fence to skate at Rodeo Park"—boomboxes blaring. Music was the lure and the heartbeat. He had been flirting with instruments since early childhood—trombone and guitar—"Self taught. Not getting anywhere." But it was another safe space for him to be in in his head.

L.A.'s creative underground pulsed with possibilities: scenes that you heard about word of mouth, scenes you simply drifted into, scenes that

began to take on a life inspired by the environments around it. The engine was in the mix of young people and music, language and flow—the way of encountering and moving through a changing world. "We'd be up at Hollywood and Highland. That northwest corner, where the mall is now, there used to be this parking lot there and all these breakdancers and graffiti artists would hang out. I remember this club called Radio and we'd go there. After the movie *Breakin'*, it became Radiotron. Radio had this summer program where they would just let kids come in during the day. So my mom would drop me off, and there was this guy, Carmelo Alvarez. He basically created a safe space for us, for the kids to decide what we wanted to do—breakdance, graffiti art, DJ, rap, hip-hop culture." Also, MacArthur Park was a teeming hip-hop hub. "Mainly Latino kids—lot of Central American kids. But there were a lot of black kids, too, taking part. I know people say Compton had its scene, but I couldn't get *down* there."

As far as he was concerned, this was the center of the universe, a coalescing at the center of his imagination. "It just felt like this is where hip-hop landed." You could feel it; the pull and the pulse.

For years, says Wil, "I just bounced around those worlds. The society we lived in, the lines were so cut for you, but I kept looking outside of that." And in Los Angeles, you could explore beyond old confines, if you knew the sidepaths. "I went from being a breakdancer, to being into hip-hop to being new wave—you know, think about it, like the line between hip-hop and KDAY and KROQ and punk and new wave was so far apart—but I was both. I *am* both. And I naturally have both of them in me. Even today, when I write music, they are both right here," he gestures with an open palm toward his center, his heart. "I was trying to be *whatever* I just wanted to be accepted. And everything really—the clubs, the music, where you chose to be—*was* about race. Here I was, as I understood it, a white boy who didn't fit in anywhere. Not with the white kids I knew. But I realized later: I could never be who I thought I was, because *I* was standing in my own way."

Finding clarity—a landing pad—meant finding other safe-spaces that were reliable, with all that was unfixed in his life. He took part in Brotherhood/ Sisterhood Camp, and it was a revelation. Not a lightning-bolt epiphany, but an awareness and comprehension that registered in stages: "I met one of the youth leaders, Dave Goldberg. I was so impressed with him. He's just like a super-solid human being, and he knows who he is. I didn't know myself, or where I was going. He always had just this heart, so I started hanging out with with him—and became more involved." Wil says that just the back-and-forth of conversation began to open up places within him. While he and his father remained in touch, their conversations rarely strayed into the territory of ancestry, or belief. "My dad never taught me that I was Jewish or what that meant. So here is this person I'm interacting with, who is calling me on my shit." Talking to Dave Goldberg, Wil learned about not just faith, the larger concept of conviction—but what that meant in the context of truly striving for unity. "I'm still working it out; it's still not worked out. But I could see it now." He didn't have to live a hidden or compartmentalized life anymore.

———— ✳ ————

All that cutting through chain link into new territories or jumping through fences to skate or write or chill, was more than a metaphor: It was to both come of age and into some sort of consciousness about what kind of man he wanted to be. Who might you be in the context of a city that was embroiled with very high profile, headline-grabbing conflict—police brutality, interracial clashes, economic disparity, street violence? How do you channel your access, alliances, and rage into action, into change? How do you work it? It was about living an integrated life, inside and out.

Music was his through line and his portal into enclaves, neighborhood, hidden outposts, and intimate friendships. "With music, I always had this drive to make it. My desire to do that was more, more than anything. Music came first. It came first before any human or any *thing*—including myself,

my well-being," he says. Those explorations and interactions, the mood and distinct textures of all those different neighborhoods, coursed through him, found expression: "The thing about L.A., you had a chance to take in so much because everyone comes here from everywhere else. Whatever music you want to do, you can find someone who does it here."

But it's bigger than that, says Wil. If you sink in deep enough, you're not simply an ally, but an intimate, have skin in the game. You take to the streets, you lend an outstretched hand, you go to the mat for your family—extended and messy, but yours. What L.A. has allowed him is not a bird's-eye view but an on-the-ground edge: "I've been to fifty-six countries with Ozo—but the thing was that I felt at home in most of them, recognized them, because L.A. prepared me for the world."

I had no business complaining about being chased out. Still. I'm ask-ing. Where are people supposed to go? Where do they *go? Does it really come down, always, to the cold, cold, hard, hard, cash?*
 —Dana Johnson, from "Buildings Talk"

AN L.A. ACCENT

You tell yourself, from a young age, "Don't get too attached"—not to the Pepto-Bismol-pink bungalows, not to wild empty lots, not to poky amusement parks, not to shade trees, not to my friends often struck by wan-derlust (or beholden to their parent's whims). Everything kept shifting, mov-ing. Blasting off. So really what made me a daughter of this place was a set of particular experiences: roads driven, neighborhoods claimed and cracked like a puzzle, slang acquired, recalled and embroidered stories that kept a feeling of home alive. That *used to be* and *once was* became as much a part of our daily discourse as grousing about traffic or home teams. Even if an ab-sence stung, seemed too abrupt, something inside of you prepared you for

its departure—I finally was just beginning to understand what fluidity meant and to study those who were better adapted to it.

"It's hard not to be nostalgic," an old high school friend mused recently upon hearing of another touchstone lost, another city block razed in its entirety, "when they keep taking everything away." But I had to wonder, if what we're feeling is really nostalgia, or rather if we are simply adrift, lost at home. This fluidness and change were inevitable (and difficult to fight) in a place where so many had come to change, and change again—and so you should find your place in it—find your flow.

Most longtime Angelenos will tell you that there are many Los Angeleses—both physical and locations of the mind. Some—of both varieties—they will caution, might fit you better than others. Finding your L.A. means giving yourself over to the city—its contours and its riddles. When you do, you'll feel it; there's an aspect of L.A. that slips under your skin. Less attitude than predilection, or frame of mind. It seeps in. Like the soot that drifts in, that finds its way through tiny gaps in your windows, the grit that powders your floors after even the mildest Santa Anas. You don't see it drifting in, accumulating, but you note the traces later. Sometimes it just startles you.

"It's a certain type of diversity, and a certain type of consciousness around that diversity and a political kind of awareness. It's the way we move through space," says Lex Steppling. "It can be a little abstract. But back then, in the '80s and '90s, Los Angeles didn't talk about itself. Not in a self-conscious way." Steppling was born in New York, but his Angeleno parents relocated back to the West Coast before he was a year old, "so, essentially this was all I knew." Upon their return, "I bounced around all over the city—Echo Park, South Los Angeles, Pasadena, Venice. I had friends of every background."

And seeing the world through their eyes shifted and sharpened Lex's perspective: It sensitized him to struggles across race and class lines across

the city. He became a quick study of the politics around geography, immigration, access, and agency: "L.A. is a very radical city, politically. And that gets downplayed. I didn't realize how lucky I was to be in such a radical city."

Each section of Southern California he lived and worked in—from suburbs to city proper—put him in intimate conversation with a cross section of Angelenos, native and transplant, all with vivid stories of their struggle, their pasts, their fears, their losses, their hoped-for futures. "When I lived in South Central L.A. my roommate was from Belize, and he had migrated at sixteen. He'd gone from this close-knit atmosphere, living on the beach. And so, you get to South Central L.A., and you're going to a school where kids are getting shot and people are dying around you, and you're scared every day. He often reflected on that," Lex remembers.

There were so many shades of these Angeleno stories from so many different perspectives—people adapting, making do, people falling through the cracks. "If you grew up in L.A., you grow up around a lot of Chicano folks and Central American folks. The '80s was so impacted by the Cold War and all the Central American refugees, people from El Salvador, so there were echoes of all of that. L.A. was a city where all of that was apparent."

And violence—flagrant or subtle, distant or nearby—colored the landscape: "You're coming off the end—not even the end of the drug wars—that era and all of that had so much to do with the Cold War, too. And the gang stuff. Even if you weren't involved, depending on where you lived, it was such a part of the fabric of your life, and back then, gangs dictated policies of the community. It was ever-present. You thought about it everywhere you went, but even *that's* always a very complicated thing to talk about because of the mix of fear and hysteria around it. Because on one hand, these are just kids, and on the other, yes, some of that was happening, and no, it wasn't what you think it was."

The experience of absorbing and memorizing neighborhoods, listening to stories and guiding people toward assistance or a next tier of possibilities,

was more far-ranging and influential than he could have known at the time.

Steppling relocated to New York to take a job in social justice and public policy, a career path, he says, that was shaped directly from his in-the-trenches experiences in L.A.—working as a youth counselor, a student leader. He's currently a national organizer for a criminal justice policy organization, JustLeadershipUSA.

"I didn't realize until I left, how transformative a place it was. You asked me how it shaped me. I'm an organizer. I meet people in my work who say: Oh, I got politicized in college, or I went to this organizing training or this development. But I learned what I learned *from* Los Angeles. From living there in a very politically charged time. I remember the riots. I remember all the organizing everyone did all the time in response to something that might have gone down. I remember Echo Park used to be full of radical Zapatista-model storefronts. That's where you went to feel good and feel safe and intellectually nourished. That's where we got our education. I didn't go to college. I was part of youth programs. I got to be a peer educator. I also spent time at NCCJ as a peer leader. I did all these things, and at the time, I didn't realize how lucky I was."

But that feeling, that elusive texture that you stumble into when people of disparate backgrounds are able to come together, find some middle ground, and create something brand new—an alliance, a garden, a marriage—that quality feels at risk. "I don't want to speak in absolutes," he cautions. "There's nuance. And still some aspects you can stumble into, but that whole set of experiences—the L.A. we're talking about—so much of that is mostly gone."

One of the characteristics that "made L.A., L.A.," says Lex, "is that it wasn't an over-curated place. It was very ethereal. It's almost like a dreamscape sometimes. People from other places struggle with that. It is not a place you can walk into and hang your hat."

That messiness, the region's sprawl, encouraged individuality—both in people and within neighborhoods. Each pocket he'd enter was unique—struggling with its own particular concerns, approaching those challenges

from their own cultural framework. "The reason L.A. was so politically radical was because people had to respond to everything from *who* they were."

As an organizer, you had to earn trust. You had to become conversant not only in other tongues, but interpersonal styles. For him, Los Angeles was a master class in the true meaning of "diversity," and why respecting cultures means *protecting* culture: Your language, your customs, your place on the map: "I think those conditions are what allow for lack of assimilation, which is why communities took hold of their areas in a certain way and didn't assimilate, held onto their uniqueness—didn't give in. I guess that's what I miss the most—and it's not there anymore. Not quite that way. And I miss those people."

"Sometimes someone will say: 'You've got this L.A. thing about you.'" The comment, he notes, might be inspired by the way he interacts with a stranger, or how he mediates conflict, or simply the way he is at home in his body.

This "L.A. thing"—*this feature* has always felt subtler to me, harder to pinpoint, I say to Lex. He considers the complexity; "I think about it here in New York. Much more now, when I have those things reflected back to me. Where I got to be, who I became. What is it to have an *L.A. accent*?. . ."

But lately trips back home to visit family and friends, unsettle him: "The heartbreak hit me about five years ago. Maybe four. I don't want to speak in absolutes, but so much of *that* is gone. In certain ways, it's heartbreaking. Remember when so many people from outside were writing rude things about us on blogs and in magazines? You just ignored it. But now? I wish they still had those opinions. Because the problem is they finally saw the real L.A., and they love it so much, they colonized it."

He pauses, reaches way back: "I miss the ease of things. Even when the city was deep in madness. Going out to grab a taco from a truck, and everybody would be out of their houses all at once, with you. Casual. Multigenerational house parties that went on and on all summer long. The space. The pace. You know, the dreamscapes."

TO STAY

For all of the blink-and-it's-gone sleight-of-hand, here in Los Angeles, the deep past can catch you unawares. Throw you for a loop. I hadn't seen my friend Corrine in decades. She'd eased away in increments—first across town, then out of the country—Europe, the Middle East. Then who knew where. In the last stage, it was so sudden and complete, like an old-fashioned long-distance telephone line that went dead. Bottomless silence. She'd vanished in a way that's difficult for people to do now, with all the fetters social media give us.

About three years ago, we found our way back to one another. By chance. She had slipped back in town, quietly, was trying on L.A. for fit. After an hours-long phone conversation, we made in-person plans and fell into a familiar back and forth. Talking, walking, and then aimless driving. Same but different. We'd daydreamed and schemed about getting here, to this stage where we alone mapped the next moves. Sometimes I'd feel the presence of those restive long-winded girls still in the backseat.

On a couple outings, feeding a sense of curiosity that was akin to sentimental, we tried to revisit old haunts: impossible. All of them gone or severely altered. One in Venice, so recently shuttered that the lights glowed in the further recesses of the dining room. We scrambled excitedly out of the car to read the handwritten "Thank you for all your years of patronage" sign, taped to the windowpane. We were too late, again, by mere moments, it seemed.

Gone were my sideroads and secret parking. Gone too was Corrine's "magic mirror" ritual, no need. She felt comfortable with the world, the world was within her.

I felt her presence, close-by, as I slogged through traffic through our old territories. Killing time before a dinner meeting, I was circling the old neighborhood in a stretch of Culver City that imperceptibly gives out into Mar Vista and then Venice, an invisible border, but when you grew up there, you

knew instinctively when it changed. A feeling. Some scent on the breeze.

From the street, the storefronts—the size and scale and shape looked familiar. Upon closer inspection, this stretch had not escaped change. There they were: the high-concept barber shops, the healing centers, the refreshed nondescript storefronts painted shades of black and dark gray. But I was energized by what still stood: the old beauty shops, auto detailers, the Brazilian market, the Argentine empanada cafe, the Indian sweets and spices and sari shop—the vividness of population and conversation that we'd grown up around.

I'd miscalculated time—left too early to avoid being late, as I often do now—the traffic, most times unpredictable—so I pulled up in front of a new coffee spot to grab a quick pick-me-up. It took a moment for me to realize that this spot used to be an old-school Chinese take-out joint—Sunday dinner, if my father was feeling a "taste for" sweet and sour, more dependable than remarkable. I paused at the door and noted from the sign that it was closing in a half hour. Inside, a few patrons, stragglers, sat on chairs and banquettes amid the overstuffed pillows, peering into laptops. I ordered an espresso and asked if I may have it "to stay." The response, albeit affirmative, was as short and bitter as the doubleshot the barista pulled and then pushed hastily across the counter. I sat on the hard bench, my back against the stiff pillow, missing that reliably standard Chinese restaurant even more so.

Still with time to kill, I climbed back behind the wheel and, on a whim, considered something I hadn't done even with Corrine. I slipped into a U-turn, and headed to her parents' old house, the site of so much of our future-dreaming. When her parents passed away, just a couple of years before mine, she made much better, quicker progress than I, moving through knick-knacks and old memories, packing them off and away. I got marooned on an island of indecision and melancholy. She was, as always, sure and ready not to be locked in.

I made the familiar right turn off the busy boulevard. The house was gone,

but the construction site is in limbo. Perhaps contested. The skeleton of a condo unit is on its way up, its footprint bulging over its limit-lines. A hulking "You-Could-Be-Home-Now" cookie-cutter ad, like all over Los Angeles.

Corrine might not know this detail about the house firsthand, as she'd, once again, moved on as abruptly as she appeared. She'd pushed away from Los Angeles like it was a kick-turn she'd made in the turquoise waters of the neighborhood plunge. Another lap. Like Wil, I know, she's ready for whatever the world might bring her.

I think about Dana Johnson and her pensive stories about vanishing people and shifting terrain as I count the windows in this new structure. Consider the arithmetic: What texture do we lose with the subtraction of lives—old neighbors and old stories? When we factor in what it might now cost to live here, even with the addition of more accommodations, what are we deprived of? What people and whose histories? Are we richer or poorer? This will be a place for only the well-to-do—and that shuts down not just the diversity of opportunity, but of possibility.

This street once had a little bit of this and that: Spanish stucco, bungalow, cottage. Kit house. It was an L.A. story of that moment—around-the-world tales. You see little evidence of what had been here; in fact, next door to the condo springing up out of Corrine's dad's old lawn, a weathered once-white post-war cottage still stands tough, but I'm sure for not much longer.

What would it be to be the last man standing? What would it feel like to draw the line in the sand? To hold on to what was left of the memory of a place? I wonder what stories of the old neighborhood remain behind that door?

"Neighborhoods aren't supposed to be museums," I'd read in a recent news story. Words from a developer defending the necessary evolution of place; how foolish it was to try to trap neighborhoods in amber. Yes. But shouldn't these places we call home, out of which we grow, harbor some sort of sense of the story that came before, some acknowledgment of what is

unique, even idiosyncratic?

Increasingly now, I understand and make peace with the fact that Los Angeles exists within us, vividly in fact. We are *its* museum. Those memories we made, those new thresholds we crossed, the chain link we cut through, the different worlds we stepped out into. That's where I suppose it will exist for those who follow us, who mindfully create a sense of home, who invest in neighborhoods and in deep friendship, who insist that this city is more than a backdrop.

Sometimes though, I can't help myself. As much as I want to keep pressing rewind—*just one more time*—Los Angeles is a fast-forward city. It always has been. I know better, I tell myself. "Keep moving."

11 *The Spirit of Place*

THE MOST EVOCATIVE FEATURES of Los Angeles can't always be put into words. Sense of place is a connection that takes root. It flourishes deep inside. That *spirit* of place may come in a quick glimpse or along a periphery. Maybe it's a mood. A hidden vista. The scale of a street. The bend of a skyscraping fan palm. Maybe it's the sound of the wind.

When I began searching for Los Angeles, I did the very thing people assume Angelenos do not. I started to intentionally walk my city to reconnect, and explore its changing face. There was the city that I could animate in words, but there was also one that eluded language, maybe purposely. After a while, I began to take along a camera to record specific details—front steps, attic windows, a tangle of succulents, the remnants of backyard incinerators, hand-drawn signs, lost lists, long shadows, the play of light, details or moments that forced me to look twice or to ask questions.

These images honor that old, over-the-hedge, conversational Los Angeles that I still stumble on from time to time. It might sprout up between the edges of poured-over concrete or be masked behind drywall, but it's there. I walk to remember and to tell and honor those stories—what still lies just outside of the frame and the images of Los Angeles that live inside of me. And us.

You see all these Cosplay kids out here in Little Tokyo in their costumes. I think, people don't realize: There are superheroes around you. You just walked past one. These heroes who worked magic in the community. So many of them are ghosts.

—traci kato-kiriyama, writer

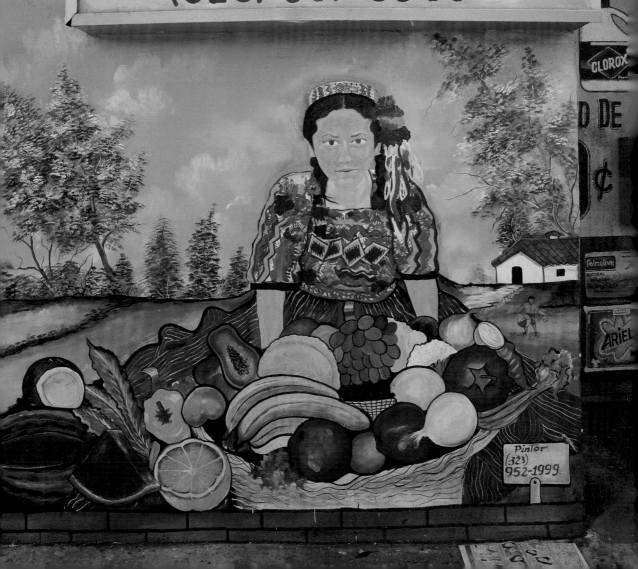

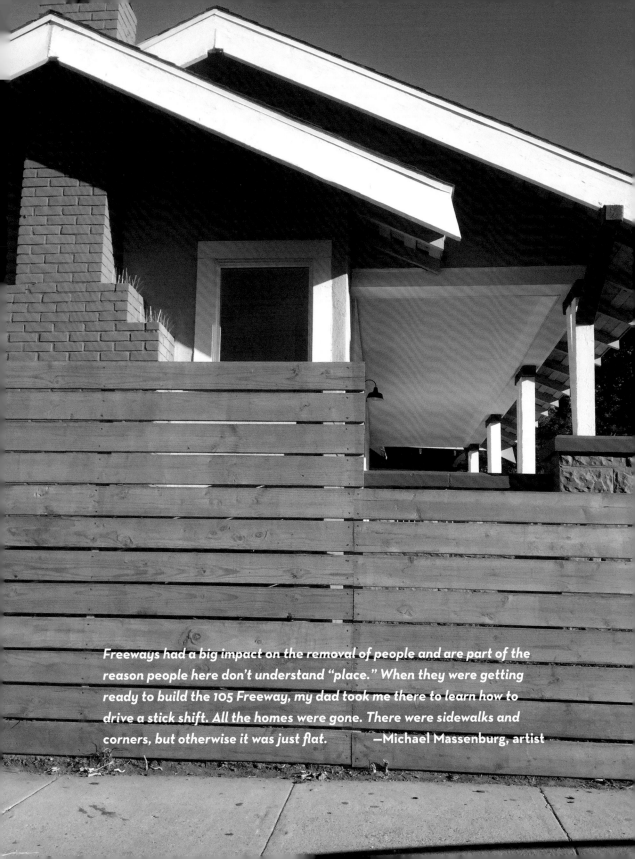

Freeways had a big impact on the removal of people and are part of the reason people here don't understand "place." When they were getting ready to build the 105 Freeway, my dad took me there to learn how to drive a stick shift. All the homes were gone. There were sidewalks and corners, but otherwise it was just flat. —Michael Massenburg, artist

Everyone had a lawn. I remember the summer sound of the grass being cut, and the lawns being watered. . . and being in the Coliseum Street School playground and smelling barbecue from the restaurant down the street.

—Robert Matsuda, musician

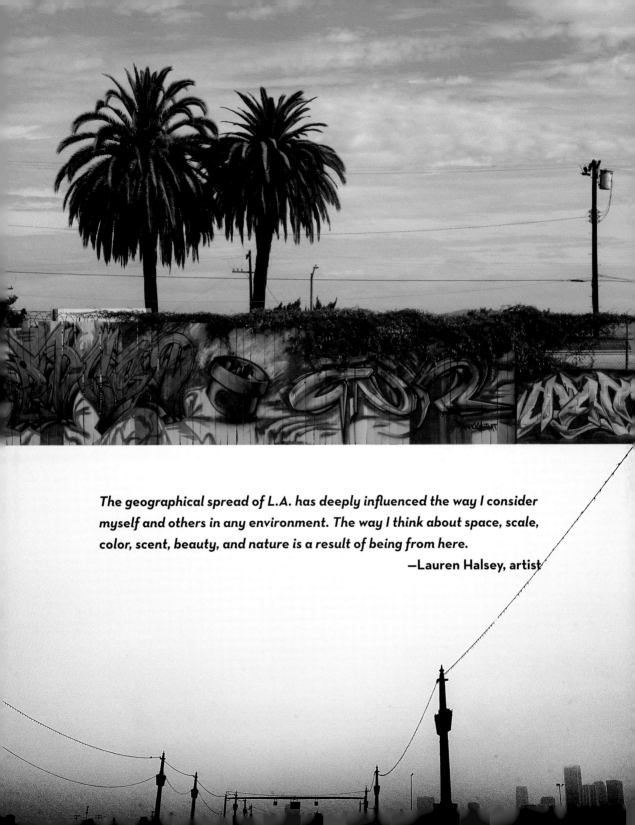

The geographical spread of L.A. has deeply influenced the way I consider myself and others in any environment. The way I think about space, scale, color, scent, beauty, and nature is a result of being from here.

—Lauren Halsey, artist

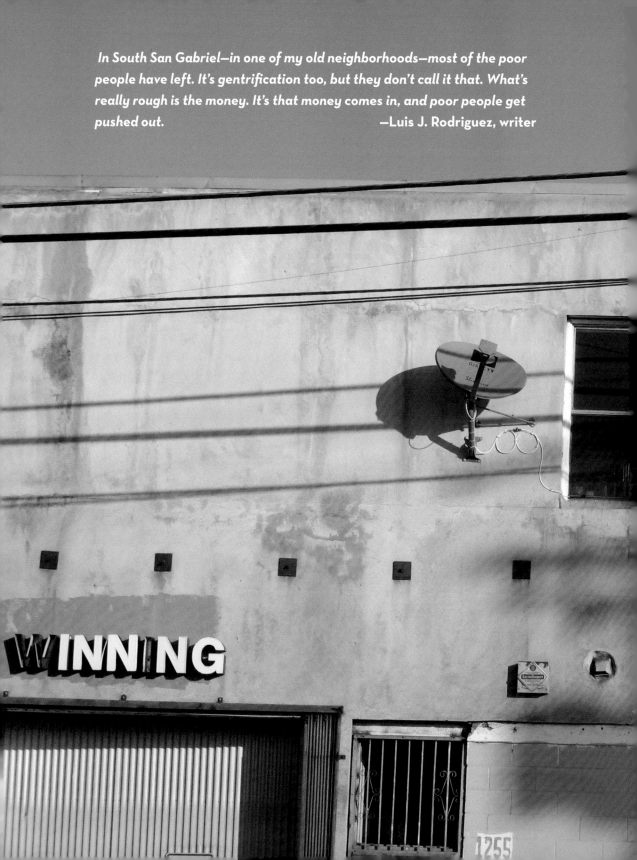

In South San Gabriel—in one of my old neighborhoods—most of the poor people have left. It's gentrification too, but they don't call it that. What's really rough is the money. It's that money comes in, and poor people get pushed out.
 —Luis J. Rodriguez, writer

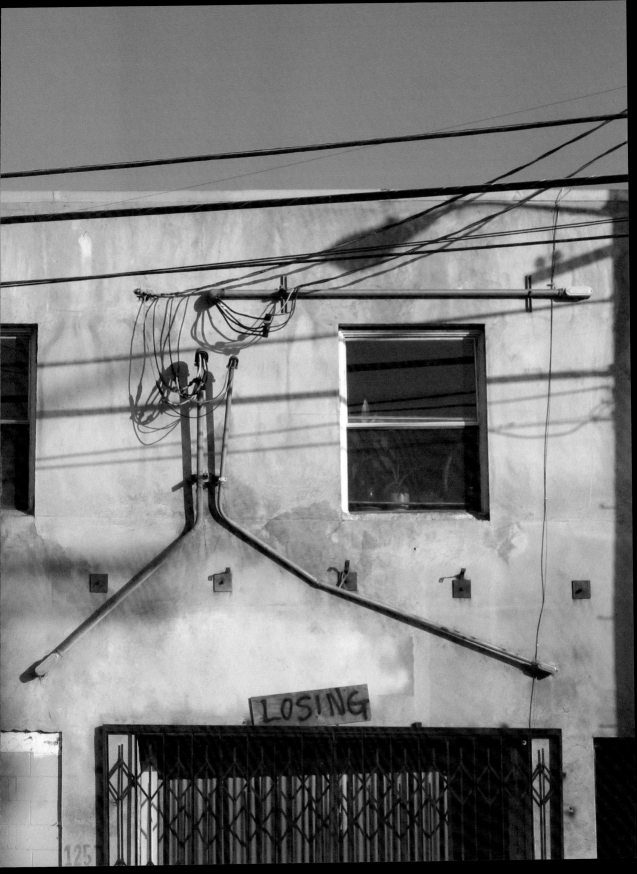

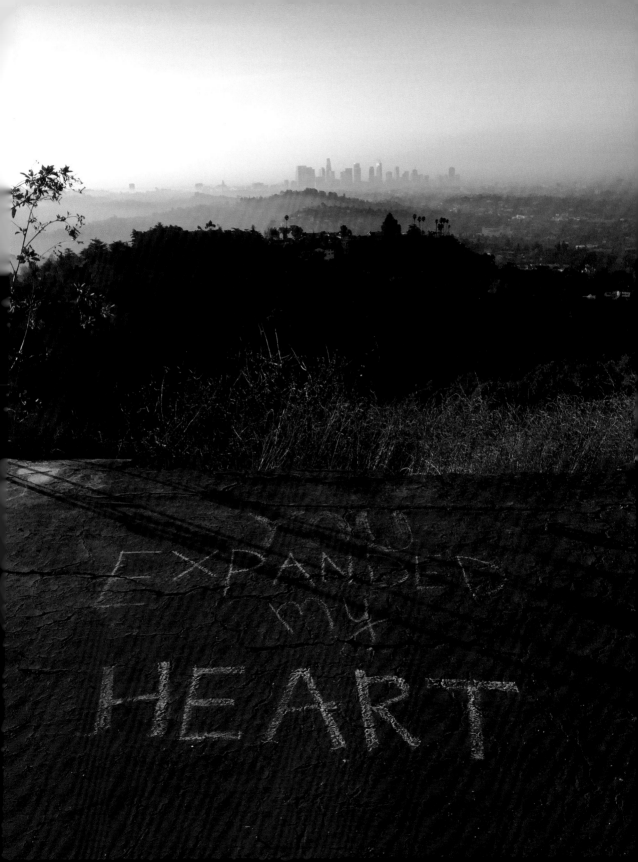

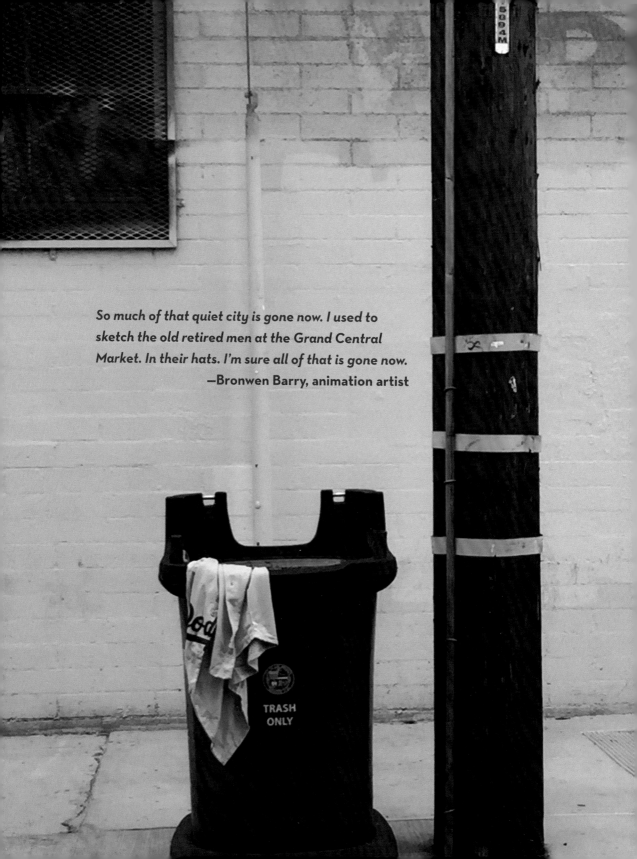

So much of that quiet city is gone now. I used to sketch the old retired men at the Grand Central Market. In their hats. I'm sure all of that is gone now.
—Bronwen Barry, animation artist

TRASH
ONLY

I thank the following people whose invitations and conversations opened the door to explore some of these ideas: Joseph Wakelee-Lynch, Laurie Ochoa, Erin Spens, Louis Warren, Carolyn de la Peña, and David Kukoff. I'd also like to thank David L. Ulin and Jon Christensen for asking, ever so casually, if I had a piece "just laying around." I would also like to express deep gratitude to Eve Bachrach and William F. Deverell, who played key roles in setting this all in motion. And a very special thanks to Louise Steinman who knows you're "working on a project" often before you do.

Writers work alone, which is why community is essential. I'd like to thank my sounding boards and writer/journalist friends who checked in—some daily—through this process: Linda Bannister, Victoria Bernal, David Davis, Janet Duckworth, Anne Fishbein, Adrienne Johnson, Erin Aubry Kaplan, Bettijane Levine, Judith Lewis Mernit, Noé Montes, Marisela Norte, the immortal Carolyn See, Jason Sexton, and Jocelyn Y. Stewart, all of whom have helped to create—and sustain—a virtual "bullpen newsroom" in my life.

To my brother, Rocky, and my dear in-the-thick-of-it, O.G. Angeleno friends—Danuta Siemak, Rubén Martinez, David Elzey, and Barbara Morgan: Thank you for helping me to reach back and access memories and territories that I'd all but forgotten. People make place.

And, of course, a beyond-words thank you to Paddy Calistro, Scott McAuley, and Amy Inouye for their creativity, generous spirits, and wall-to-wall support in making this book come to life.

Most of all, to my parents, Elodie and Leonard, whose Los Angeles dreams brought us here.

—Lynell George

Lynell George is a journalist and essayist. *After/Image: Los Angeles Outside the Frame* is her first book of essays and photography, exploring the city where she grew up. She is also the author of *No Crystal Stair: African Americans in the City of Angels*, a collection of features and essays drawn from her reportage. As a staff writer for both the *Los Angeles Times* and *L.A. Weekly*, she focused on social issues, human behavior, and identity politics, as well as visual arts, music, and literature. She taught journalism at Loyola Marymount University in Los Angeles, in 2013 was named a USC Annenberg/Getty Arts Journalism Fellow, and in 2017 received the Huntington Library's Alan Jutzi Fellowship for her studies of California writer Octavia E. Butler. Her writings have appeared in several essay collections. A contributing arts-and-culture columnist for KCET|Artbound, her commentary has also been featured in numerous news and feature outlets including *Boom: A Journal of California*, *Smithsonian*, *Zócalo Public Square*, *Los Angeles Review of Books*, *Vibe*, *Chicago Tribune*, *Washington Post*, *Essence*, *Black Clock*, and *Ms.* Her liner notes for *Otis Redding Live at the Whisky a Go Go* earned a 2017 GRAMMY nomination.

Photo: Victoria Bern

After/Image: Los Angeles Outside the Frame • By Lynell George
Copyright © 2017 Lynell George • Design by Amy Inouye, Future Studio
ISBN-13 978-1-62640-053-5 (print edition) • ISBN-13 978-1-62640-054-2 (e-pub edition)
Versions of some essays first appeared in these publications: Chapter 2, in *Southern California Review* Issue 7. It was also listed as one of the "Notable Essays and Literary Nonfiction of 2014" in *The Best American Essays 2015*. Chapter 3, in *Slake: Los Angeles*, Issue 4: 2012. Chapter 4, in *Los Angeles in the 1970s: Weird Scenes Inside the Gold Mine*. Chapter 5, in *Boom: A Journal of California*, Spring 2013, Vol. 3, No.1. Chapter 6, in *Boat Magazine*, 2014. Octavia E. Butler quotation, courtesy The Huntington Library, San Marino, California.

Published by Angel City Press • 2118 Wilshire Blvd. #880 • Santa Monica, California 90403
+1.310.395.9982 • www.angelcitypress.com

ANGEL CITY PRESS

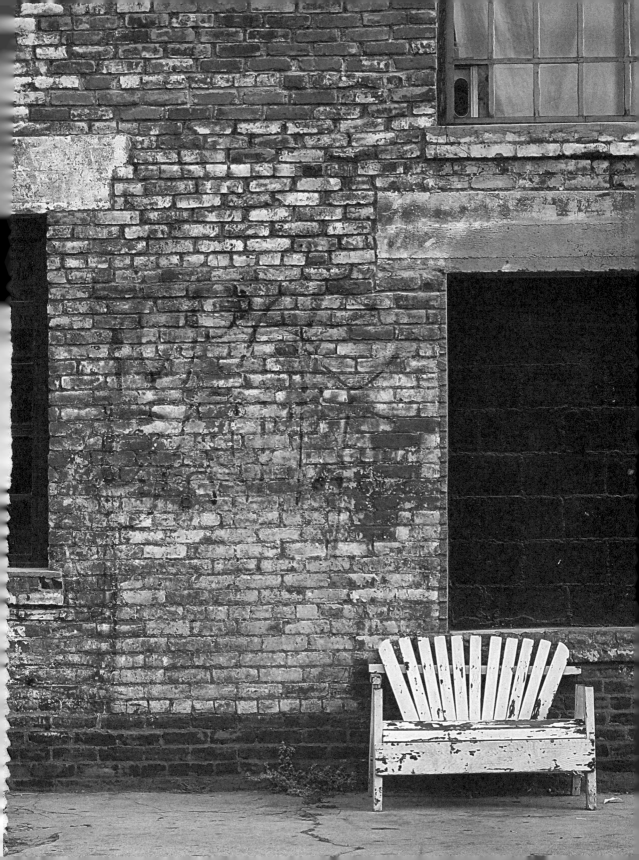